IMAGES
*of America*

# STRONGSVILLE

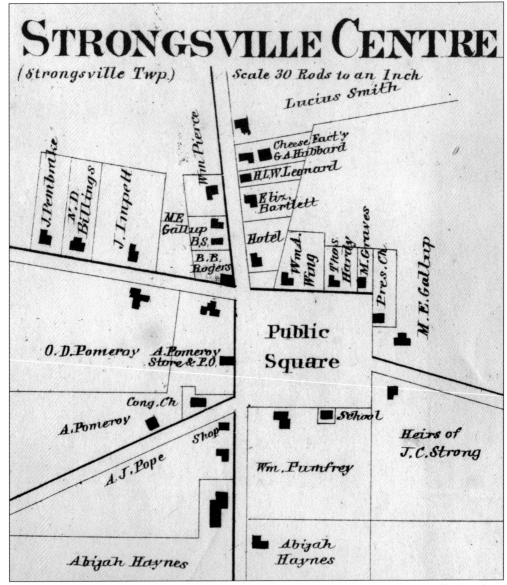

This 1874 map depicts the area of Strongsville where Pearl Road (State Route 42), Royalton Road (State Route 82), and Westwood Drive converge at the center of the city. At the time of the illustration, the population of Strongsville Township was approximately 900.

On the cover: In 1822, John Stoughton Strong deeded the land now known as the commons (at Pearl and Royalton Roads), along with land for the Strongsville Cemetery, to the residents of Strongsville Township for the consideration of $1. The commons is shown on the cover in the early 1900s. The only structure in the photograph still standing is the Old Town Hall, which was constructed in 1879. In addition to being the seat of government, it has served countless other uses for well over a century. The Old Town Hall remains a living symbol of the history of Strongsville. (Strongsville Historical Society.)

# IMAGES of America
# STRONGSVILLE

Bruce M. Courey

Copyright © 2006 by Bruce M. Courey
ISBN 0-7385-4126-5

Published by Arcadia Publishing
Charleston SC, Chicago IL, Portsmouth NH, San Francisco CA

Printed in the United States of America

Library of Congress Catalog Card Number: 2006933973

For all general information contact Arcadia Publishing at:
Telephone 843-853-2070
Fax 843-853-0044
E-mail sales@arcadiapublishing.com
For customer service and orders:
Toll-Free 1-888-313-2665

Visit us on the Internet at www.arcadiapublishing.com

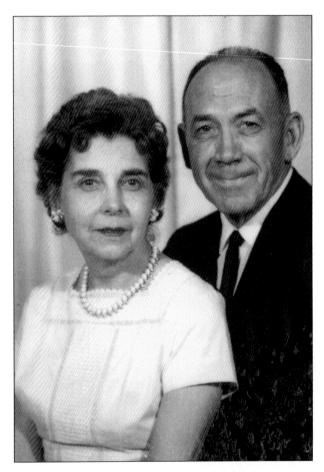

Howard Chapman (1899–1988) and Velda Chapman (1903–1991), the founders of the Strongsville Historical Society and Village, dedicated their lives to their community and left as their legacy the enduring preservation of Strongsville's heritage.

# Contents

| | | |
|---|---|---|
| Acknowledgments | | 6 |
| Introduction | | 7 |
| 1. | Strongsville's Own | 9 |
| 2. | Historical Homes, Buildings, and Landmarks | 29 |
| 3. | Strongsville Then and Now | 51 |
| 4. | Government and Business | 63 |
| 5. | Life at the Crossroads | 89 |

# ACKNOWLEDGMENTS

I extend my sincerest gratitude and appreciation to Karen Lehman, board member and curator of the Strongsville Historical Society. Karen opened up the archives, helped me examine hundreds of photographs, checked my historical accuracy, and guided me through every step in the process. This book could not have been completed without her. Thank you to the following members of the historical society board of directors for supporting this project: Jane Laffoon, Ruth Brickley, Nina Hummel, Barbara Shearer, Glen Laffoon, Gina Cathcart, Anne Ehrnfelt, Ruth Mitchell, Robert Mittelstaedt, Pam Hughes, Dave Sharkey, Don Maatz, RosaLee Walters, and Ann Woollett. Thank you to Louise Varisco and Carol Williams for skillfully proofreading the text.

I am grateful to Strongsville native Lynn Duchez-Bycko, associate in Special Collections at Cleveland State University Library, for providing additional images and introducing me to the scanning process. Kristen Oravec at the Strongsville Public Library also gave assistance.

Unless otherwise noted, the Strongsville Historical Society provided the photographs for this book. Images from Cleveland State's Special Collections are cited as CSU. Thank you to the following for providing additional photographs and/or firsthand information that could not be found elsewhere: Mary Arpidone, Louise Morton Bedford, Mike Catan, Anne Ehrnfelt, Bernice Ferry, former mayor Dale Finley, Alan Hirt, Carole Maatz, Gayle Spadaro, Lee Sprague, the collection of Bruce Young, the staff of Whitney Elementary, the staff of St. Joseph Church, councilman Joe DeMio, and Mayor Tom Perciak and his staff. Special thanks go to Amy Anter for her photography skills.

Thank you to my editor at Arcadia Publishing, Melissa Basilone, for guiding me through my first book-writing experience.

Thank you to my parents, Ron and Shirley Courey, who gave (and still give) their unconditional love and support, and who always wanted tenfold for me any goal I set for myself.

Finally I want to extend my most heartfelt gratitude to my wife, Peggy, and my children, Christine and Ryan, who gave their unyielding love, support, and patience as I worked on the book day after day in my spare time. Peggy was always the first to examine my work and to let me know when something clicked (and when it did not). When I told her I wanted to do this, all she ever did was want it for me as well. It is because of Peggy that I am blessed beyond words, and it is to her that I dedicate this book.

# Introduction

The federal government in the 1780s was still in its infancy, and there were quarrels among several of the original 13 states regarding claims for western lands. Congress encouraged states claiming lands in the Northwest Territory to cede them so that the government could regulate their sale and authority. On September 14, 1786, Connecticut surrendered to the government all its western land claims except for 3,333,699 acres extending 120 miles from Pennsylvania into northeastern Ohio. This land, called the Connecticut Western Reserve, was sold by the state for $1.2 million to a group of investors known as the Connecticut Land Company in 1795. One of its seven directors, Moses Cleaveland, arrived at the mouth of the Cuyahoga River in 1796 and plotted a "capital city" for the Western Reserve that was named Cleaveland (later Cleveland) in his honor.

The Connecticut Land Company directed the surveying and division of the land into separate townships and its sale to eager settlers from New England. Moses Cleaveland negotiated a treaty whereby the Iroquois Indians gave up claim to land east of the Cuyahoga River. Ohio became the 17th state in 1803, and other Native American tribes agreed to give up land west of the Cuyahoga in 1805. One year later, surveying was completed, and the land was divided into separate parcels and sold off to Connecticut Land Company members. One of those members was Oliver Ellsworth of Hartford, Connecticut, an original member of the U.S. Senate and later chief justice of the U.S. Supreme Court. Township No. 5, 14th Range of the Western Reserve, was among thousands of acres deeded to Ellsworth in 1807 and, upon his death soon after, inherited by his sons William and Henry.

Following the War of 1812, the Ellsworths searched for assistance in managing the sale of their township lands. In 1815, they reached an agreement with a 44-year-old Marlboro, Vermont, businessman and farmer named John Stoughton Strong to purchase several thousand acres of Township No. 5, 14th Range. Strong further agreed to act as agent on commission for sale of the remaining parcels of the township to other settlers. As a result, by 1816 he owned or controlled most of this 25-square-mile area of land. That year, Strong led a group of pioneers to the Western Reserve, traveling south along the Rocky River to Columbia and east to Township No. 5. The group included his eldest son, Emory Strong; Elijah Lyman; Guilford Whitney; John Hilliard, his wife, Bernicey (daughter of Guilford), and his daughter Eliza; William Fuller; and Obadiah Church. Land was cleared and log cabins built, and the township was surveyed into 100 lots of 160 acres each.

By agreement with the Ellsworths, Strong was to sell 21 lots per year at $2.50 per acre in consideration for purchasing 7 lots at $1.50 per acre. Much of the land was purchased with cattle

obtained from Ohio, Kentucky, and Indiana, and for the next 21 years, Strong personally drove the cattle to markets in New York, Pennsylvania, and New England. Settlers from these states soon began moving into the area, which was organized as a township on February 25, 1818, and called Strongsville. Strong took the lead in developing the settlement and overseeing establishment of the roads, schools, churches, various businesses, and the township's first sawmill, gristmill, and flour mill. He brought in people with specialized skills, including Dr. William Baldwin to replace his deceased son-in-law as town doctor. He donated a parcel of land that later became known as the commons, similar to the permanent open space found in New England towns. Strong also donated the land for the Strongsville Cemetery. A log cabin built on the commons served as the town hall, schoolhouse, and church. By 1820, the population had reached 297 and the first roads were constructed. In 1826, there were 89 households, and a year later, the main road through Strongsville became a stagecoach turnpike known as the Wooster Pike (Pearl Road). By 1840, there were 1,151 people in Strongsville Township, although it would be nearly another 100 years before the population would reach 2,000.

From its founding in 1818 up to World War II, the chief occupation in Strongsville was farming and agriculture. With their New England roots, many farmers also raised sheep, and the constant threats to their flocks from wild animals resulted in the Hinckley Hunt of 1818 and the Wolf Hunt of 1888. Residents often traveled on foot or by horse and buggy, or stagecoach if one traveled to Cleveland or to points south along the Wooster Pike. The Cleveland Southwestern Interurban Railway, an electric rail line built from Cleveland through Strongsville to Wooster, opened in 1903. The interurban provided convenient access to downtown Cleveland, directly affecting the revenue streams of area farmers and helping to modernize Strongsville and other rural areas along the railway. The advent of the automobile and Green Line bus service had signaled the end of the interurban by 1931.

In 1927, residents voted to incorporate their township as a village, resulting in a mayor-council form of government with building and zoning code regulations. Roads were improved, more automobiles were purchased, population increased, and Strongsville's agricultural character steadily began to erode in the 1940s and 1950s. Pres. Dwight D. Eisenhower implemented construction of the interstate highway system, and the Ohio Turnpike was completed in Strongsville in 1955, followed by Interstate 71 a decade later. The village was incorporated as a city in 1961, and suddenly a farming community of 2,200 in 1940 was fast approaching 10,000 residents. Between 1955 and 1968, six elementary schools were built. Farmlands became residential neighborhoods, shopping areas, and industrial parkland. Strongsville began to develop a business-friendly reputation, stressing the importance of expanding income tax revenue to maintain a high level of services. At the same time, the city's connection to the Cleveland Metroparks system allowed for the preservation of miles of green space.

With its rural character becoming a thing of the past, Strongsville began growing more rapidly. A population of 8,500 in 1960 had more than tripled to over 28,500 by 1980. Walter F. Ehrnfelt's 25-year tenure as mayor began in 1978, during which time residential development and the industrial tax base continued to expand. In addition, the city saw the construction of its new library, its Recreation and Senior Center, and one of Ohio's largest shopping malls. The 2000 census placed Strongsville as the 13th-fastest-growing city in Ohio, with a population of 43,858.

Strongsville has evolved from its humble beginnings as a small farming village into a dynamic city offering homes in every price range, businesses and industries of all types, excellent schools, and a full range of services and amenities to enhance the quality of life for its residents. Yet throughout its nearly two centuries, Strongsville has always maintained its small-town charm and has always celebrated its rich history. This book is a visual look back at some of the people, places, and events that helped shape the destiny of the place I am proud to call home.

# *One*
# STRONGSVILLE'S OWN

Strongsville is still the home of individuals and families who can trace their lineage back to the city's earliest years. Many names from the past are familiar because their descendants still live there and can boast with pride that, like their parents and grandparents and great-grandparents before them, they have spent their entire lives in Strongsville. Marriages between prominent families over time have reinforced an unmistakable sense of community pride and a connection to the past, and some people can point to several historical names and reference a relationship by blood or marriage to each of them. Other names may stand out because of their daily prominence on a street sign, historic landmark, elementary school, restaurant, or storefront. There are residents who remember a time when everyone knew almost everyone else, when the high school graduating class was less than 50 students, and when their city with small-town charm really was just a small town.

Some of the people in this chapter were lifelong Strongsville residents who made some large or small contribution to their hometown. Some were born there and went on to other accomplishments beyond the city limits. Others came from different states or countries, found their way to Strongsville, and eventually played a part in guiding its destiny. In the following pages are some of the people who can rightfully be called Strongsville's own.

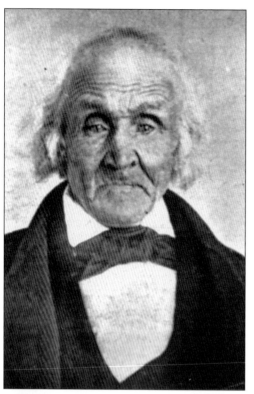

This is the only known photograph of John Stoughton Strong, born in Connecticut in 1771. The son of a Revolutionary War veteran, his arrival in the Connecticut Western Reserve's Township No. 5, 14th Range, in 1816 is recognized as the birth of the city that bears his name. He lived in Strongsville for the remainder of his life and died in 1863 at age 91.

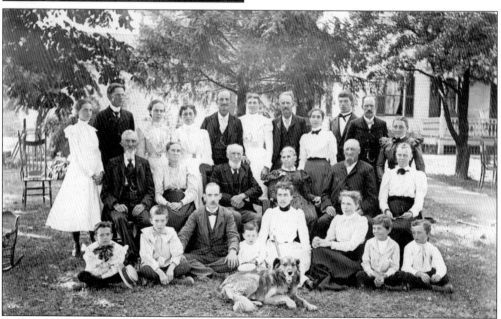

The first reunion of the Strong family took place at the home of David Merrick Strong on his 70th birthday, August 22, 1899. Seated from left to right in the second row are Lorenzo Strong and his wife, Lois Strong (née Austin); David Merrick Strong and his wife, Almira Strong (née Bryant); and George B. Strong and his wife, Hattie Strong (née Aylard). Lorenzo and George were grandsons of John Stoughton Strong.

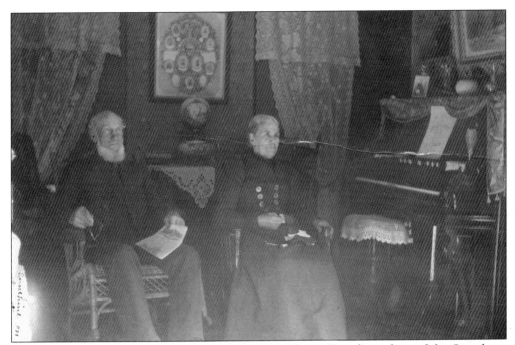

David Merrick Strong is pictured here with his wife, Almira. David's uncle was John Stoughton Strong, and his grandfather was Guilford Whitney. The Strongs were married for 53 years and died in 1906 within 16 days of each other.

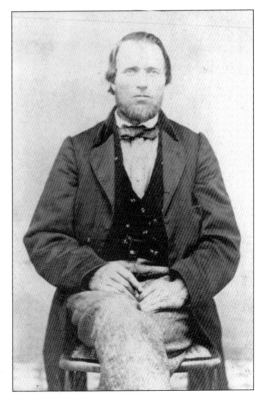

Charles Drake was born in Strongsville in 1822. Drake Road was named for his father, Asa, who had walked the entire route from Stoughton, Massachusetts, to the township in 1820, becoming the first of the Drake family to settle in Strongsville. Charles eventually moved with his wife, Elizabeth Beaham Drake, to Bennett's Corners, near what is now the intersection of Boston Road and West 130th Street. He died in 1889.

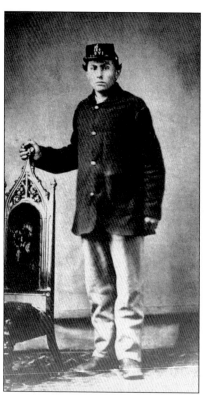

Shown in May 1862 as a 16-year-old Civil War soldier, Samuel A. Carpenter later lost his right arm in battle while fighting for the Union army. He was the last surviving Strongsville veteran of the Civil War at the time of his death in 1928 at age 82.

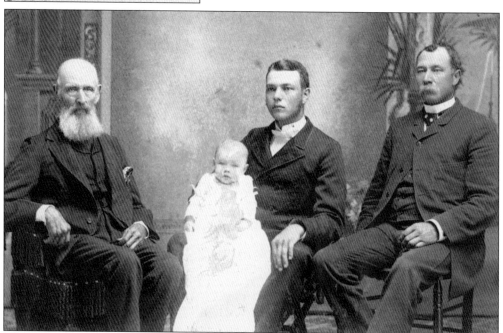

Four generations of the Howe family pose in the early 1890s. Pictured here, from left to right, are Zara Davis Howe Jr., baby Glenn, Carl, and Frederick. In 1818, Zara Jr. came to Strongsville to live on the land his father (for whom Howe Road is named) had purchased from John Stoughton Strong. He lived there until his death in 1892, shortly after this photograph was taken.

Joseph Webster, seen with his wife, Melinda Millar Webster, settled in the northeast area of Strongsville in 1836 with his father, mother, and younger sister. The house where they resided still stands on Webster Road, which was named for Joseph's father, Phineas. A relative, Noah Webster, first wrote the *American Dictionary of the English Language* in 1828, and the Webster name has become synonymous with the modern dictionary.

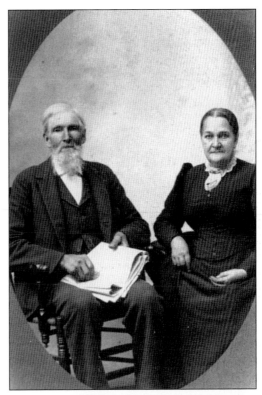

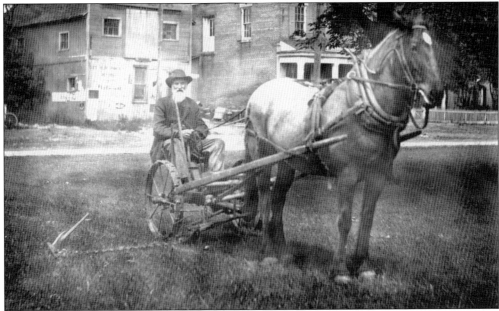

Wilbur Bradley and his wife lived on Depot Street (now Westwood Drive) beginning in 1897. Bradley served as Strongsville's maintenance department at the time of this 1912 photograph, in which he mows the lawn on the commons. Behind him are the Howe and Clement Store (left) and the Benbow and Clark General Store, originally the general store that Alanson Pomeroy built next to his residence in 1850.

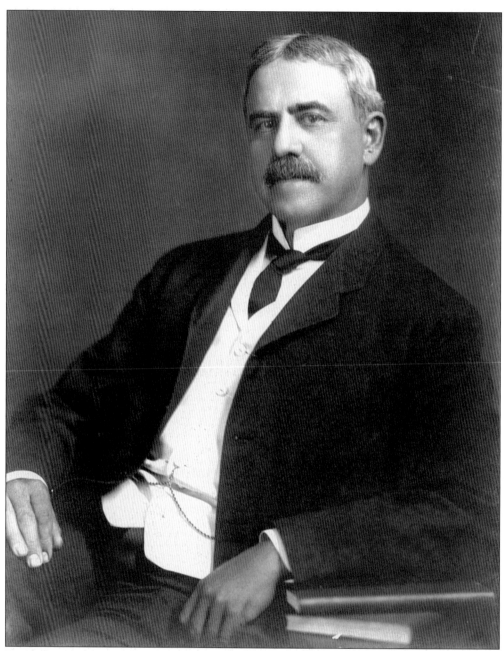

Dr. Harlan Pomeroy, shown here as a distinguished Cleveland physician, was the youngest son of Alanson Pomeroy. Alanson's prominence in Strongsville history dates back to 1835. Serving as a township trustee and justice of the peace, he was known to residents as Judge Pomeroy. He built his residence, known as the Homestead, in 1848 and his general store in 1850, donating the adjacent land for the Congregational Church in 1853. Harlan Pomeroy, his brothers Alson and Orlando, and his brother-in-law Charles Miller formed the group that built the Cleveland Southwestern Interurban Railway. Harlan eventually bought out his fellow heirs and set up the Homestead as a summer residence. It remained in the family after his death in 1911, and his daughter Gertrude was the last Pomeroy to occupy the Homestead when she moved out in 1963.

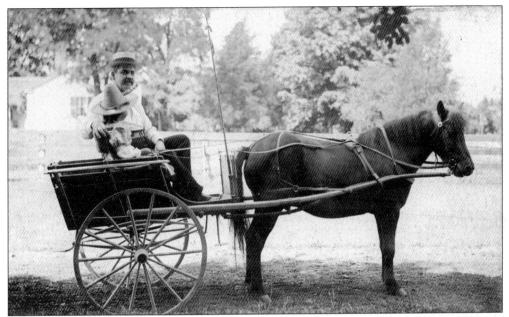

Dr. Harlan Pomeroy and his daughter Gertrude are seated aboard a two-wheeled wagon with Jim Crow, Gertrude's pony, around 1900.

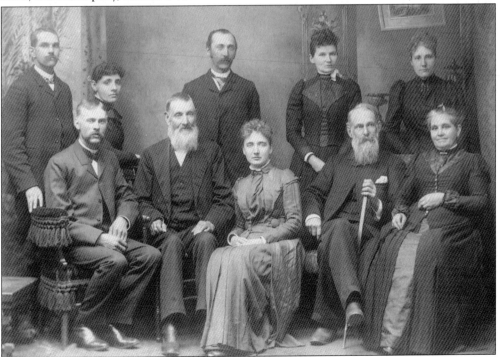

This late-19th-century photograph includes, from left to right, the following: (first row) Albert Bedford, William Clement, Florence Bedford, unidentified, and Selena Clark; (second row) Charles Clark, Annie Clark, Thomas Clement, Florrie Clement, and unidentified. At the site of the old Pomeroy Store, Thomas Clement operated the Howe and Clement Store with Carl Howe. Charles Clark later partnered with Charles Benbow in the Benbow and Clark General Store.

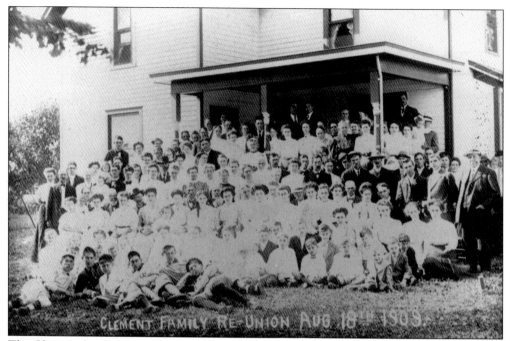

The Clement family reunions were first held in the 1890s and continued for many decades into the 20th century. The reunion above took place at the C. H. Clark home in the summer of 1909. Such events were not uncommon during that period.

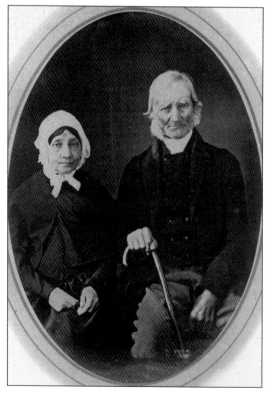

Born in England in 1807, Thomas Bedford came to Strongsville with his first wife, Harriet, and his parents, William and Elizabeth Bedford, in 1834, along with the families of Richard Clement and John Benbow. The three families settled on adjacent farms on Friendship Street (later Benbow Road). Thomas is shown here in the 1880s with his second wife, Selina Clement Bedford, whom he married a year after Harriet's death in 1843.

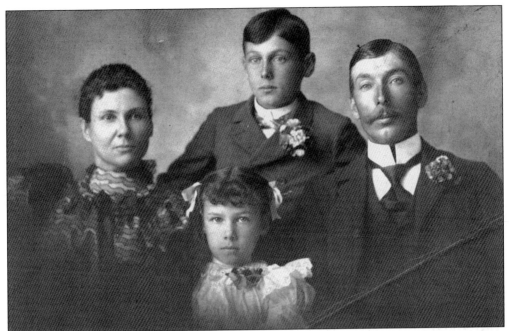

Thomas Bedford's son Lawrence poses in the late 1890s with his wife, Cora, and his children Gerald and Lila. Lawrence operated the Bedford-Howe Hardware Store with his nephew Carl Howe in the building he constructed next to what is now the Strongsville Café. He also served periodically as a trustee of Strongsville Township between 1902 and 1923.

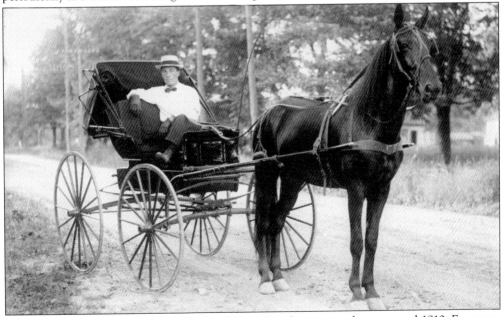

Lawrence Bedford's daughter Lila married Harry Burnham, seen above around 1910. For many years, he managed a grocery business, Burnham's Cash Store, in the building once housing his father-in-law's hardware store. Burnham also owned an insurance agency and later operated a mink ranch on Shurmer Road. The mode of transportation and stretch of dirt road shown here were typical of early-20th-century Strongsville.

Eldon (left) and Arlene (below) Roe are pictured in 1986 inside the Academy at the Strongsville Historical Village. Eldon was born in Strongsville in 1913, the youngest of four children of Elias Roe and Mary Kaatz Roe. His parents were active in the Strongsville United Methodist Church and, for 26 years, promoted the annual lawn fete at their Pearl Road home, across the street from the church. That home, now known as the Roe-Chapman House, is part of the historical village. In 1937, Eldon Roe took over management of his father's millinery chain, E. P. Roe Stores, purchasing it in 1941. Arlene was a teacher in Rocky River and Strongsville. A collection of Roe hats are on display at the Academy.

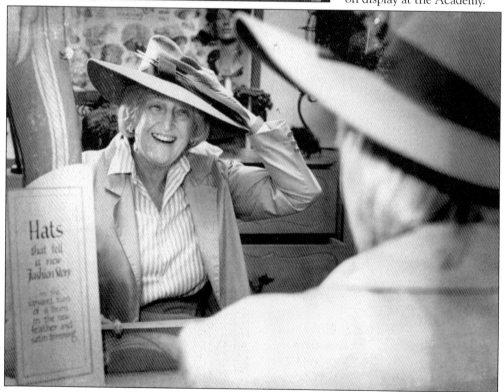

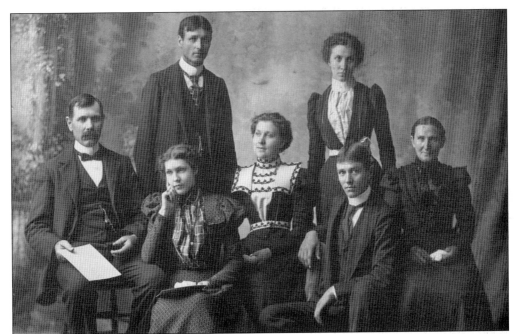

Frederick Maatz married Emilie Kruger in Berea in 1870. Shown here in 1900, the family includes, from left to right, the following: (first row) Frederick, Emma, Mae, Arthur, and Emilie Maatz; (second row) Fred and Jennie Maatz. Frederick Maatz purchased a farm on Albion Road in 1882, and the 1893 house he built on that property still stands. (Carole Maatz.)

Elmer Drake, a descendant of early Strongsville settler Asa Drake, married Thomas Bedford's daughter Cora in 1888. The Drakes pose in 1905 with their son Leland and daughter Velda.

Velda Drake and Howard Chapman, pictured in their high school days, were married in 1923. Howard grew up on Route 303 in Brunswick. He later embarked on a distinguished teaching career in Parma, Bay Village, Brooklyn, and, beginning in 1936, in Strongsville. He also served three terms on city council. Howard Chapman Elementary School was dedicated on Drake Road in 1971. Velda Chapman's lineage traces to Strongsville's earliest days, when her great-uncle Asa Drake settled in the township in 1820, followed by her great-grandfather William Bedford in 1834. She was renowned for her original paintings of local historical landmarks. The Chapmans organized the Strongsville Historical Society from their Pearl Road home in 1962. In 1976, they deeded a portion of their property (and later bequeathed the remainder) to the society and established the city's unique historical village. They were married for 65 years.

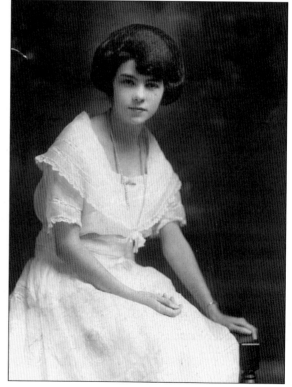

James Bartlett, who settled in Strongsville in 1852, is shown in the early 1900s with his second wife, Florence Hunt Bartlett. He served four years as a township trustee and was a road and bridge builder by trade. Bartlett was instrumental in securing Wooster Pike (now Pearl Road) as the first brick road to run through Strongsville.

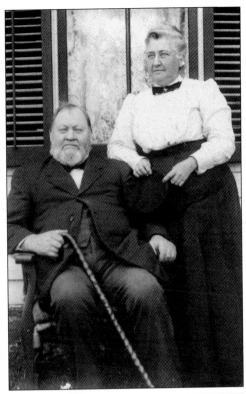

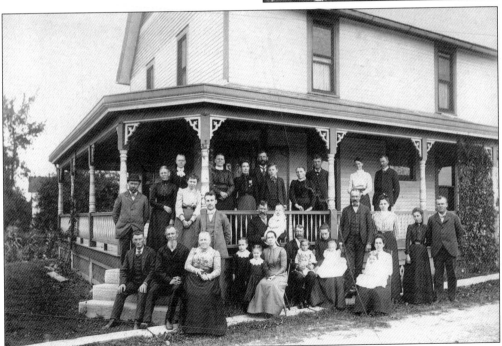

The William Wheller family is depicted in the early 1900s. William and his two sons operated a blacksmith and machine shop near this home on Pearl Road north of Westwood Drive, near the present location of Crossroads Market Plaza.

Gathered in the early 1900s, from left to right, are Arthur, Lucy, and Frederick V. Stone. Lucy Gallup Stone authored *The History of Strongsville*, published in 1901 as the first definitive chronicle of the township.

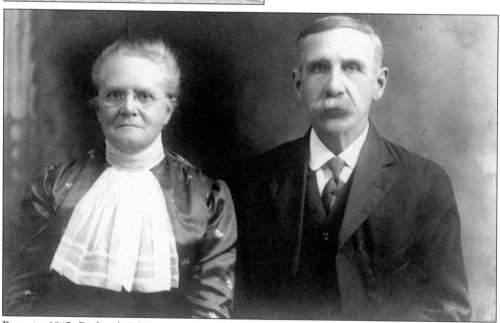

Born in 1845, Richard Gibbons came to Strongsville from England with his parents in 1855. He served as a deacon in the Congregational Church and as clerk of the school board when Strongsville High School was built in 1908. Gibbons married three sisters of the Robbins family, two of whom predeceased him (Anne and Mary Jane). He is pictured here with his third wife, the former Elizabeth Robbins.

The grandson of Alanson Pomeroy, Dr. Dayton C. Miller was born in Strongsville in 1866. His father, Charles Miller, helped develop the Cleveland Southwestern Interurban Railway. Dr. Miller was head of the physics department at the Case School of Applied Science (Case Western Reserve University) for 41 years. Also an accomplished musician and an acoustics expert, he is renowned for his 1896 invention of the first American photographic X-ray machine. (CSU.)

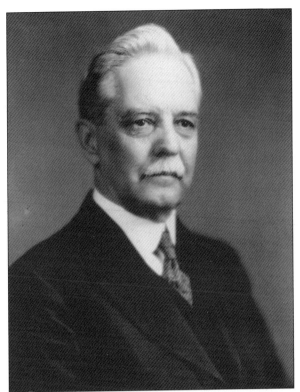

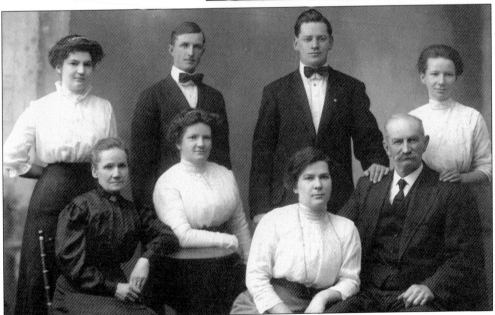

The Charles Ogilvy family gathers for a photograph in the early 1900s. Pictured here, from left to right, are the following: (first row) Ida Ogilvy, Nellie Ogilvy Poots, Ruby Ogilvy Bedford, and Charles Ogilvy; (second row) Isabel Ogilvy Sanderson, Clarence Ogilvy, Arthur Ogilvy, and Florence Ogilvy Killian. Charles's father, Walter, a Scottish immigrant, purchased a farm on Lunn Road after settling in Strongsville in 1844.

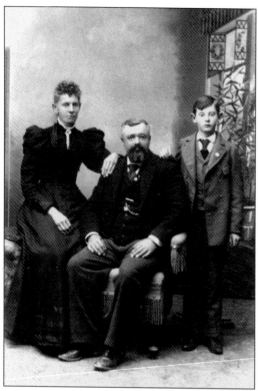

Richard Pierce poses in the 1890s with his wife, Julia Green Pierce, and his youngest son, Roy. The Pierce family occupied a farm on Prospect Road, just north of Lunn Road. Roy went on to found and operate a wholesale meat business, later establishing Pierce Motor Sales, a longtime Strongsville automobile dealership.

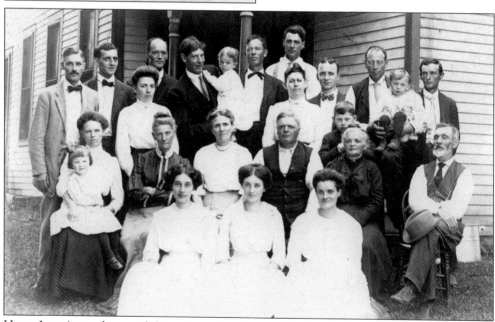

Henry Lant (second row, right) immigrated to Strongsville from England in 1867. For 23 years, he operated the grain elevator at Prospect Road and Westwood Drive. In the late 1800s, he owned the mill originally built by John Stoughton Strong in 1820. Also depicted in this early-1900s photograph are Julia Green Pierce (second row, second from left) and Roy Pierce (third row, fourth from left), holding son Ralph.

Three generations of the Poots family are represented in this 1890s image. Shown here, from left to right, are Samuel Poots, his son, Ellsworth Poots, and his father, John Poots. John, an Irish immigrant, settled in Strongsville in 1854 and lived there until 1892. He died in Berea in 1901. Samuel was a cattle buyer who lived on a Boston Road farm for 40 years. Ellsworth served as Strongsville's postmaster for 17 years.

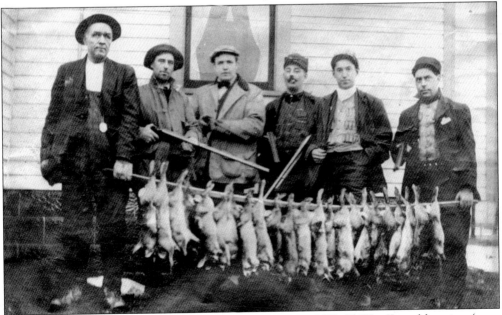

Strongsville was predominantly a farming community until World War II, and hunting (even rabbit hunting) was still a common daily event in the early 20th century, when this photograph was taken. Charles Poots, a Spanish-American War veteran and son of John Poots, is pictured at left, along with brothers Joseph (second from left) and Frank Siedel (right). The brothers owned Siedel's General Store at Prospect Road and Westwood Drive.

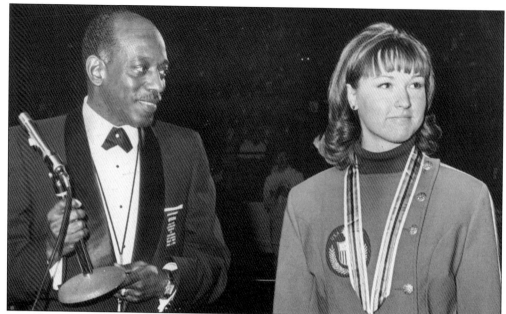

Jenny Fish, a Strongsville native and great-great-granddaughter of John Poots, won a silver medal in the 500-meter speed skating event at the 1968 Winter Olympics in Grenoble, France. Hers was one of five U.S. silver medals won at the Games, with the only American gold medal going to figure skater Peggy Fleming. Here she poses with Harrison Dillard, Olympic track-and-field gold medalist of 1948 and 1952. (CSU.)

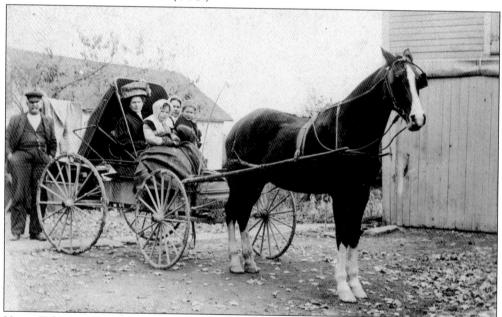

Henry Whitman Merrick was the younger son of Edgar Merrick, who built the Methodist church at Albion in 1842. Henry is shown standing in 1909 with (from left to right) his wife, Gertrude, daughter Helen, maid Lulu Bell, son Leonard, and Kitty Horse. Henry, a farmer and township trustee, served for 12 years as justice of the peace. Helen later married Sylvester R. Zellers, a longtime Strongsville schoolteacher.

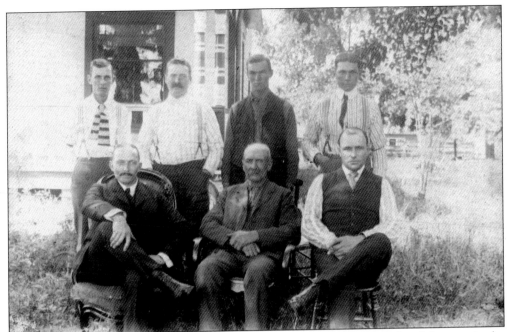

Joseph Merrick (first row, center), the elder son of Edgar Merrick, is pictured with his sons in the early 1900s. Born in Strongsville in 1841, he fought for the Union army for three years during the Civil War. Charles Merrick (first row, right) founded the Merrick Chevrolet Company in Berea in 1915.

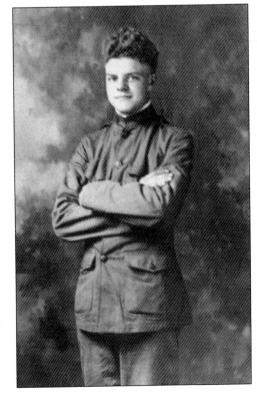

Paul Hirt, the eldest son of Samuel and Anna Hirt, served as a soldier during World War I. He became one of Strongsville's two casualties of that conflict when his troop ship HMS *Otranto* sank off the northeast coast of Ireland in October 1918, one month before the war's end.

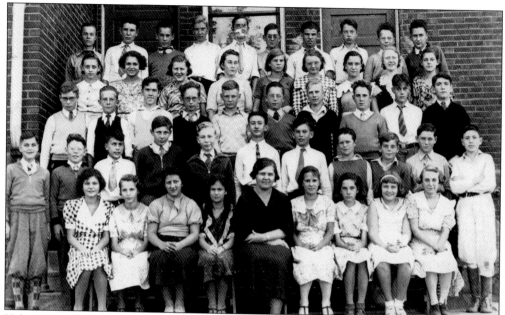

Helen Muraski (first row, center) taught Strongsville's eighth-grade class in 1934–1935. Lee Sprague appears in the fifth row, third from left. The son of Strongsville mayor Ben Sprague, Lee has served as a councilman, recreation board member, hospital board member, homecoming chairman, bus driver, and volunteer firefighter, among other capacities. He can still be found tending the flower gardens at the Strongsville Historical Village.

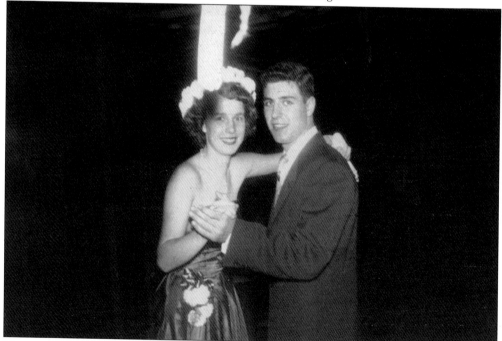

Homecoming queen Anne Fligle and football team captain Walter F. Ehrnfelt dance at Strongsville High's homecoming in the fall of 1950. The future mayor and his date were married soon after their graduation in 1951. (Anne Ehrnfelt.)

# Two

# HISTORICAL HOMES, BUILDINGS, AND LANDMARKS

In 1834, Benjamin Northrup came from Albion, New York, and settled on the east branch of the Rocky River along the Wooster Pike, near the mill that John Stoughton Strong had built in 1820. Other mills, churches, schools, and businesses were soon constructed, and the community was named Albion. This area became a main stop on the stagecoach route along the turnpike. After a fire wiped out most of Albion in the 1840s and a railroad was built through Berea in 1850, it began to decline.

Other sections of Strongsville Township developed their own names and, even for a time in some cases, had their own post offices. Beebetown, which contained various businesses, a cheese factory, a school, and even a crude oil pumping station, was located near Marks and Boston Roads. Bennett's Corners was a busy community at the township's southeast corner, and to the present day the area is known by that name. A mile up Bennett's Corners Road (Hunt Road) at Drake Road was a bustling area known as Sanderson Corners. Slab Hollow, with its own mills, shops, and schoolhouse, stood near Royalton Road and what is now Mill Hollow Lane. At Prospect Road and Westwood Drive, at the convergence of the Baltimore and Ohio Railroad and the Cleveland Southwestern Interurban Railway, one had to be vigilant as passenger and cargo trains crossed through the area; thus, the community was known as Vigil. Farther north on Prospect were Johnston's Corners at Albion Road, Dyke's Corners at Fair Road, and Sprague Town at Sprague Road.

A visual history of Strongsville is not complete without a look at its historical homes, buildings, and other landmarks. Some have stood proudly through many decades as the city developed and evolved dramatically around them, while others exist only in photographs. In either case, one only need take a walk through the Strongsville Historical Village as proof that this is a community that uniquely respects and celebrates its heritage. In this chapter are a few of the past and present historical venues that help to tell the story of Strongsville.

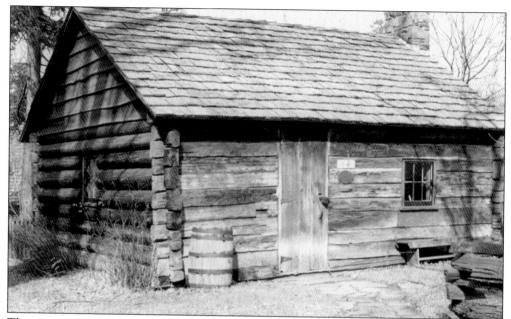

The temporary cabins constructed for the 1916 centennial and 1966 sesquicentennial are not to be confused with the log cabin built permanently at the Strongsville Historical Village in 1976. This cabin was a replica from Strongsville's earliest days in 1816 and the first of several stages in the construction of the village, a unique collection of original homes and buildings reflecting life in Strongsville in the 19th and early 20th centuries.

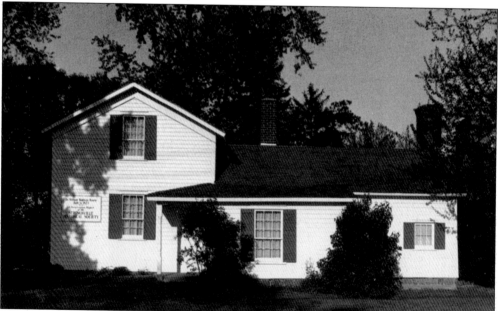

Dr. William Baldwin, an early town doctor of Strongsville, built this Western Reserve cottage in 1823 on the site of the Pomeroy House. It was later moved behind the nearby site of the Congregational Church sometime before the Pomeroy House was built in 1848. One of the first wood-frame residences in the township, the Baldwin House was transported to the historical village in 1980.

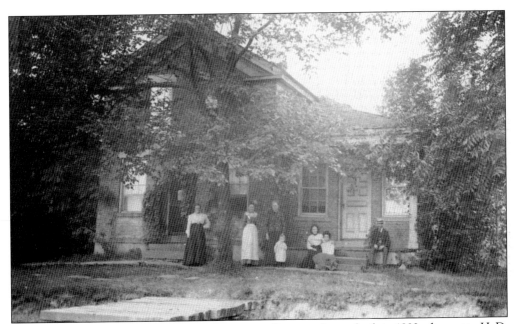

The Bradley House, depicted in this 19th-century photograph, was built in 1832 adjacent to H. D. Bradley's tavern and store in Albion. The structure survived the fire that had destroyed Albion's main business district in the winter of 1843–1844. The builder of this house is believed to have also built the Pomeroy House, as the woodwork in both is virtually identical. The Bradley House was moved along with the Lathrop House to the historical village in 1988.

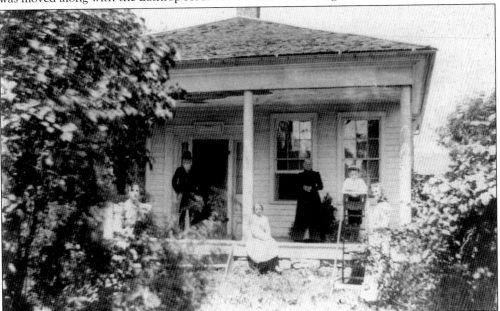

The Academy was a private school built in 1842 near the commons. Later purchased as a residence by the Graves family, shown above, it was relocated to the historical village in 1983. Today the Academy showcases artifacts from Strongsville's one-room schoolhouses, as well as the Roe Millinery's extensive historical collection of women's hats. In addition, the notorious animal killed in the Wolf Hunt of 1888 is preserved here.

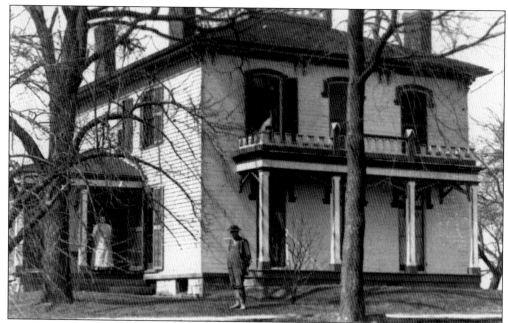

The Lathrop House, seen in its original setting at the top of the hill in Albion, was built in the 1870s by Hazen Lathrop. Hazen was the son of Thaddeus Lathrop, the first miller at John Stoughton Strong's Albion mill in 1820. The home was relocated to the Strongsville Historical Village in 1988.

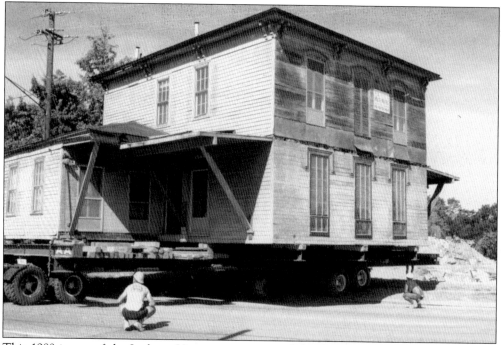

This 1988 image of the Lathrop House moving exemplifies the painstaking process by which structures were brought in to create the city's one-of-a-kind historical village. Before its relocation, the Lathrop House was in danger of being razed at its original Pearl Road site.

The Roe-Chapman House was built in the early 1900s by Wesley Pepper, a local builder who constructed many of the township's homes and buildings at that time. Elias Roe purchased the residence in 1907. Only this house and its barn, along with the replica log cabin, were actually built on the site of the future historical village. In 1957, the home was sold to Howard and Velda Chapman.

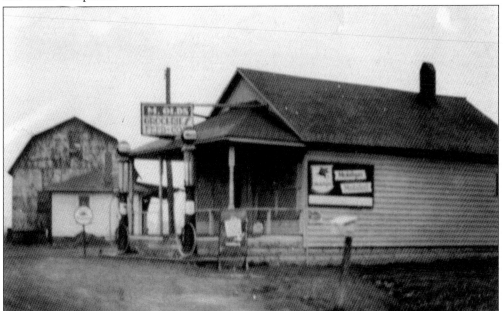

Mortimer Olds operated his general store from 1927 to 1964 at Marks and Boston Roads in Beebetown. Coal and general merchandise were sold, and the coal heating stove found inside was a meeting place for neighbors. Shown here at Beebetown, the store was moved to the historical village in 1987. It now serves as the village gift shop and contains many artifacts of merchandise typical of a country store.

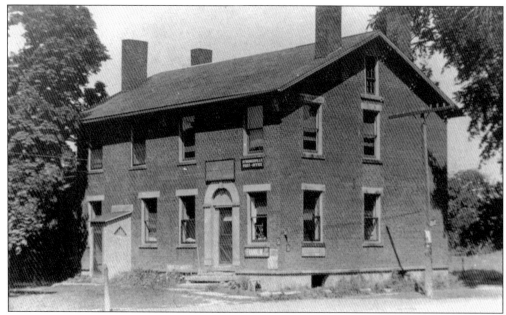

John Stoughton Strong built this home in 1833 and lived there until his death. In the early 1900s, it served as a post office, as seen above. It has also been a general store and an apartment house, where future mayor Walter F. Ehrnfelt and his wife, Anne, lived as newlyweds in the early 1950s. Today the Strong House is currently an orthodontist's office. It is listed on the National Register of Historic Places.

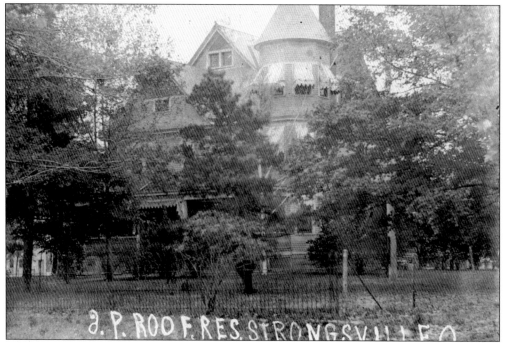

J. P. Roof built this mansion in 1891 on the commons, near the site of the current city hall and police station. This photograph was taken around 1910. A stone from the original gatepost can be found in the Strongsville Historical Village.

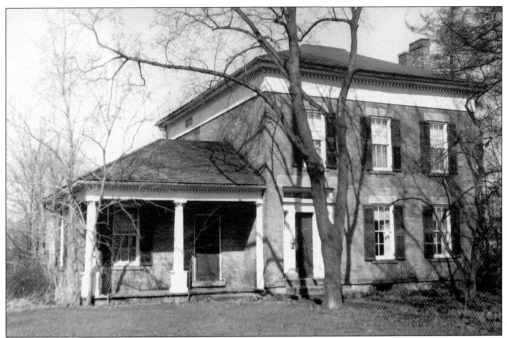

Alanson Pomeroy constructed his home at Pearl Road and Westwood Drive in 1848. Shown from the front (above) and rear (below), the residence was known as the Homestead for more than a century. Pomeroy was an active member of the Congregational Church, which was built in 1853 adjacent to his general store and his home. Worshippers who lived too far away were invited to stay for dinner, and the spare room was made available for travelers. During the Civil War, Pomeroy's abolitionist beliefs compelled him to set up the Homestead as a station of the Underground Railroad, secretly hiding runaway slaves in the cellar and providing them with food. Pomeroy would conceal slaves in loads of hay and take them by wagon to Rocky River to boats leaving for Canada.

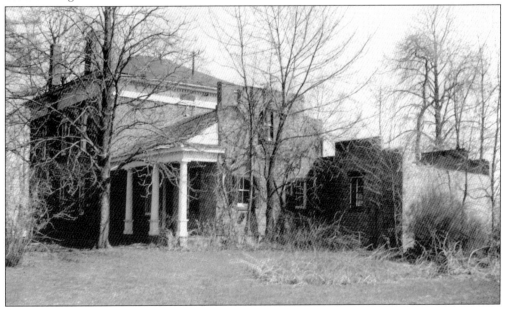

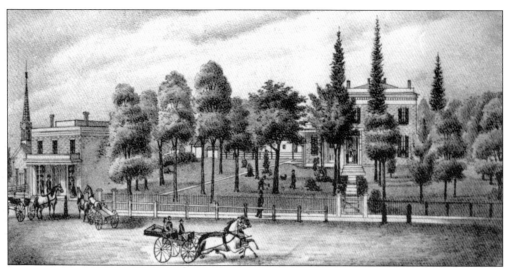

This drawing from an 1874 atlas of Cuyahoga County, Ohio, depicts the Congregational Church, the Pomeroy General Store, and the Pomeroy House from their early years in the 1850s.

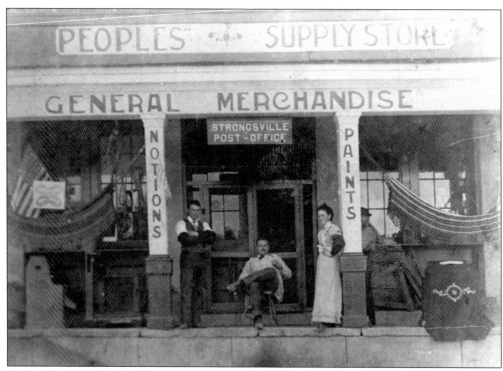

The Pomeroy General Store underwent several different uses over the years. At the time of this 19th-century photograph, it operated as the Peoples Supply Store but also served as the township post office.

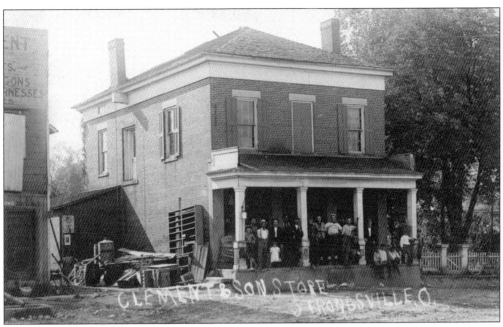

Thomas Clement and his son Vernice ran a general store and feed business from the old Pomeroy Store in partnership with Carl Howe, beginning in the 1890s, as seen above. At the time, the Howe and Clement Store also served as the post office, from which Ernest Fish later began the first rural mail delivery to Strongsville in May 1905. Clement was postmaster. The general store eventually became the business partnership of Charles Clark and Charles Benbow (son of John Benbow). The photograph below was taken around 1912. After many years of service as a grocery, feed, and merchandise store, the building became the Tea Room and Restaurant. It was razed in the late 1930s.

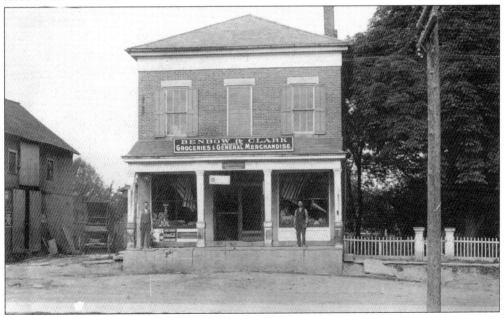

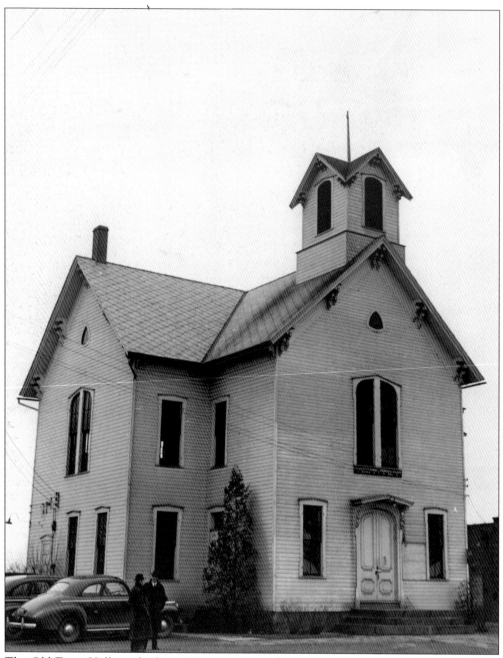

The Old Town Hall was built in 1879 at a cost of $3,945. A contest was held between local farmers to see who could first get the lumber to the township to construct the building, with a gallon of whiskey as the prize. The building replaced a log cabin that had operated as Strongsville's first town hall for more than 50 years. The Old Town Hall has served as a municipal and police facility, a jail, a political debate hall, a school, and a library, among other capacities. When this photograph was taken in December 1941, two days before the Japanese attack on Pearl Harbor, it doubled as the home of Strongsville Grange No. 1324. A new town hall was dedicated across the street in 1952. (CSU.)

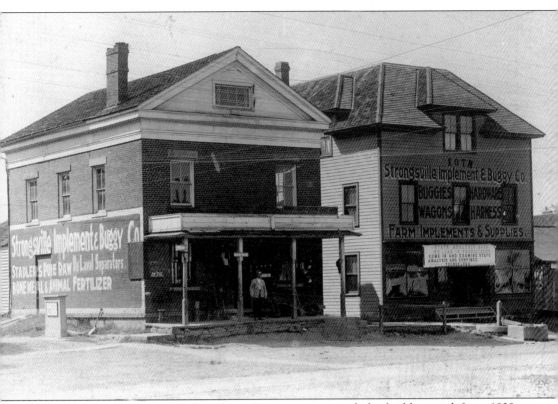

Warner Strong, a son of John Stoughton Strong, constructed the building at left in 1839. This photograph was taken at the start of the 20th century, when the building housed the Strongsville Implement and Buggy Company. Joseph Szentpetery purchased the property in 1920 and established a general store and lunchroom. Still standing at the corner of Pearl Road and Westwood Drive, it has long been the site of the Strongsville Café. Lawrence Bedford built the structure at right and eventually opened a grocery and hardware store with his partner, Carl Howe. It later became Burnham's Cash Store, owned and operated by Bedford's son-in-law Harry Burnham.

George Ordner's house on his 60-acre farm stood just east of the Old Town Hall. It was later demolished in 1965 when Royalton Road was expanded. Ordner was married to Emma Drake, daughter of Charles Drake and granddaughter of early settler Asa Drake. In this 1940s photograph, the Congregational Church can just barely be seen in the distance beyond the automobile, looking west on Royalton Road approaching Pearl Road.

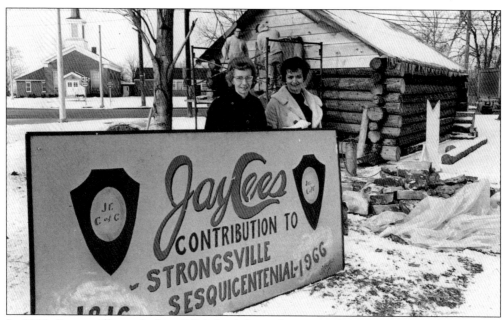

In 1966, Strongsville marked its 150th birthday with a citywide sesquicentennial. Sponsored by the chamber of commerce, the sesquicentennial was celebrated with a series of projects and events throughout the year. The Strongsville Jaycees constructed a replica log cabin on the commons for the occasion. City hall secretaries Wanda Korfel (left) and Natalie King stand next to the nearly completed cabin. (CSU.)

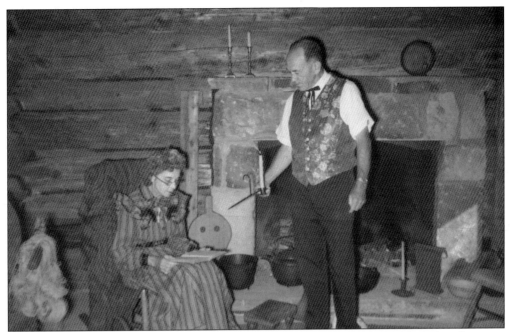

Strongsville Historical Society founders Howard and Velda Chapman were elected cochairmen of the Sesquicentennial Committee. They are shown above in the interior of the completed replica log cabin in 1966. Their vision for replicating the city's heritage culminated in the 1970s and 1980s with the creation and growth of the city's historical village.

Grant Atkinson, the first mayor of Strongsville, lived in this home on Pearl Road from 1904 until his death in 1936. It later became the dental office of Dr. Fred Colbrunn. The home is now a commercial building in its original location between the commons and the Strongsville Cemetery. With many alterations, it currently bears little resemblance to this structure of the late 19th century.

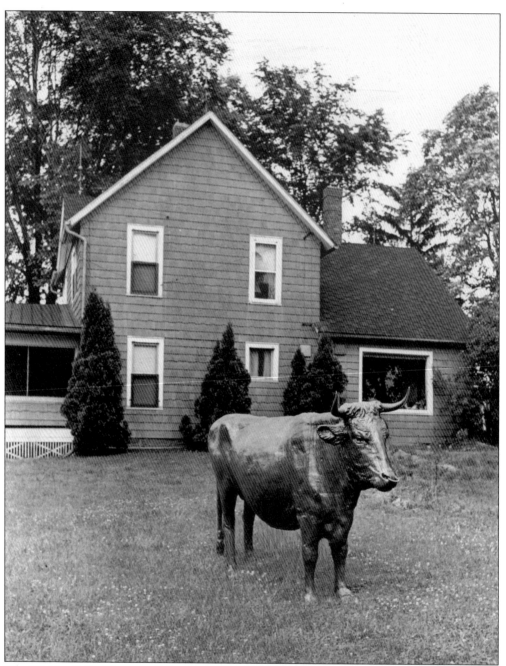

The "Golden Bull of Strongsville" is depicted in front of the Pearl Road home of Walter Ehrnfelt Sr., whose son Walter became the longtime mayor of Strongsville. The bull was brought from Chicago in 1893 and placed atop the Nelson Morris Meat Company on Ontario Street, across from the Central Market in downtown Cleveland. When that building was demolished in the 1920s, Walter Sr.'s father, Gottlieb Ehrnfelt, purchased the bull and moved it to the location above, where it stood for many years. A Burger King restaurant now occupies the site of the house, and the bull remains in the possession of the Ehrnfelt family. A fixture for years in the annual homecoming parade, the bull is of unknown construction. (CSU.)

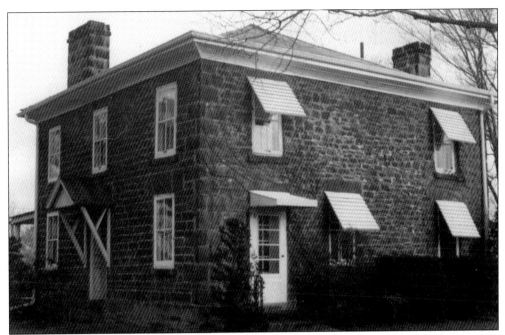

Franklin Strong, the son of John Stoughton Strong, came to Strongsville in 1818 at age 11 with his father. In 1836, he built this unique home on the top of Stone Hill. Constructed with quarried stone obtained on-site, the home still stands at its original location on Pearl Road, just north of Boston Road.

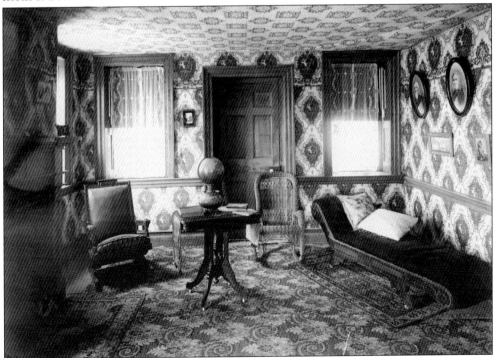

This early-20th-century photograph shows the interior of the Franklin Strong home, which at one time contained eight fireplaces.

Before he founded the Standard Oil Company and later became the world's first billionaire, John D. Rockefeller was a Cleveland boarding school student who lived with his family in this home in Strongsville. The Rockefellers arrived in the township in 1853 and settled on a 35-acre farm on Whitney Road. The home has long been razed, but the residential development adjacent to that location is known as the Rockefeller Estate.

William Shurmer came to Strongsville in 1873 and purchased a 175-acre farm on the road that now bears his name. The farm included the area's largest cheese factory, shown above, which was owned and operated by Grant Atkinson until the beginning of the 20th century.

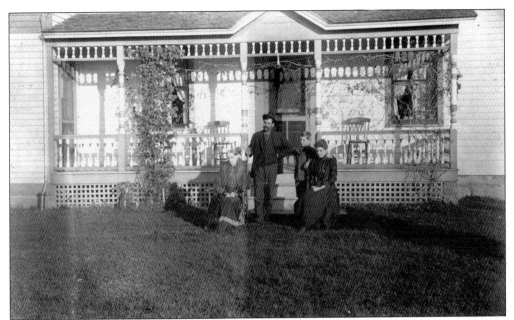

The central portion of this home was originally built on Friendship Street (now Benbow Road) by early Strongsville pioneer William Bedford. Elmer Drake later purchased the home and moved it to the area of Bennett's Corners (now Hunt) and Boston Roads in 1893. Drake is pictured in the 1890s with, from left to right, his mother-in-law, Selina Bedford; his son Leland; and his wife, Cora.

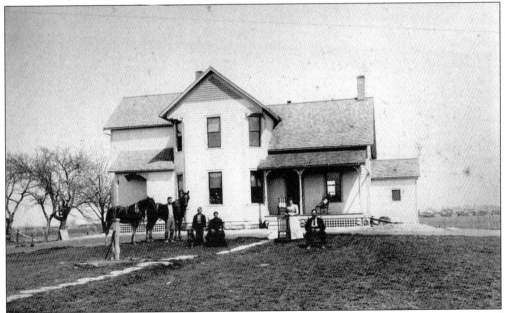

This home, built by Frederick Maatz in 1893 on his Albion Road farm, still stands just east of Priem Road. Shown here in 1895 are, from left to right, Frederick's sons, Fred and Arthur; his wife, Emilia; his daughter, Mae; and Maatz himself. Arthur lived on the farm until his death in 1967, and his daughter Carole still resides there. Over a century later, the home remains in excellent condition. (Carole Maatz.)

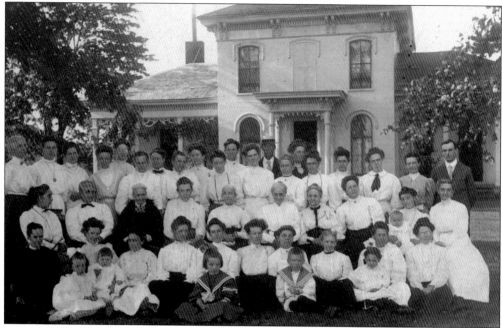

This Congregational Church gathering took place in 1903 at the Frederick Stone home, which was later owned by Arthur Budweg and eventually listed on the National Register of Historic Places. It stood on Lunn Road from the mid-19th century until its demolition in the late 1990s.

Carpenter Edgar Merrick helped build the home of Jefferson Davis in Biloxi, Mississippi, before moving to Strongsville in 1839. He constructed this homestead on his Drake Road farm a year later. After a coin flip, Merrick's son Henry and his wife lived with his parents in this house, and son Joseph lived across the road. Shown above in 1904, the house still stands just west of Howe Road.

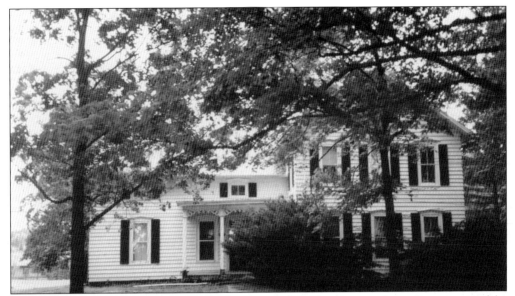

This Victorian home was built in 1873 by Rev. A. W. Knowlton and was later occupied by Dr. James B. McConnell until he sold it to William Ehrbar in 1904. Known as the "Strongsville Historian," Ehrbar lived in the house for more than 40 years before William Cumberworth purchased it. The residence stood on Shurmer Road near Pearl Road and was razed in 1999 to make way for the Altenheim Retirement Community.

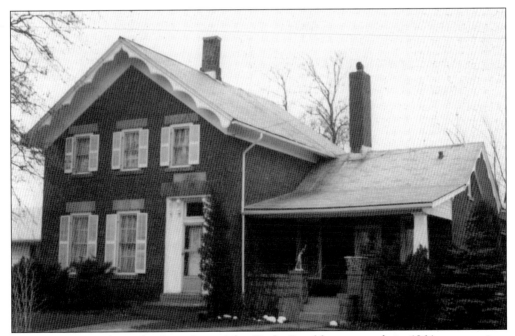

The cornerstone above the front door of this Drake Road home reveals its 1864 construction. Aretus Sanderson, and later his son Allison, lived here, in the area that was once a thriving business community known as Sanderson Corners. A sawmill, a basket factory, a carriage shop, and a schoolhouse once occupied this region. The home still stands just west of Hunt Road.

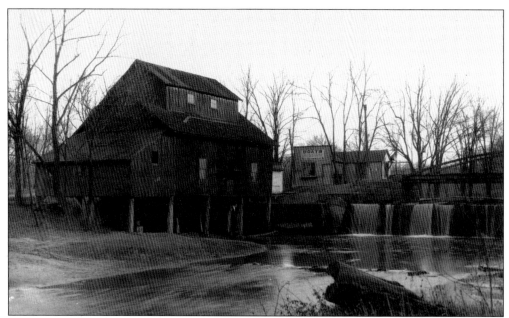

John Stoughton Strong built this mill in 1820 on the Rocky River in Albion, near what is now Bonnie Park. A catalyst for area development, the mill operated for many decades at that location and was razed in 1937 as the Cleveland Metroparks developed and expanded. This photograph was taken in 1920. Visitors to Bonnie Park today can still see the dam and the foundation for the bridge. (Bruce Young.)

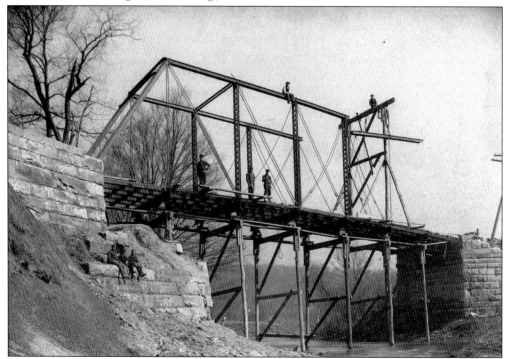

This late-1800s photograph shows the construction of the Wooster Pike bridge over the Rocky River at Bonnie Park. Pearl Road still traverses the river at this site near Albion Road.

Roy's Mill, seen to the right in the early 1900s and below in 1930, was built in 1835 near what is now Camp Cheerful. Cornelius and Maatje Roy purchased the mill in 1888 and took over operations a year later with their 16-year-old son, William, as manager. In 1892, the mill began manufacture and marketing of Roy's Pride Flour. The Roy Milling Company was formed in 1900, and William assumed full control of the mill in 1907. The Roy family repeatedly modernized the mill, including the additions of steam and later diesel power, modern machinery for grinding feed, and a rye, graham, and buckwheat mill. The family leased the mill to Joseph Harwood in 1944 after running the business for 55 years. In 1948, after 113 years of continuous operation, the structure was destroyed by fire. (CSU.)

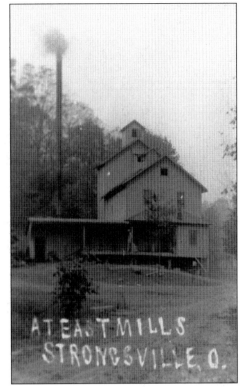

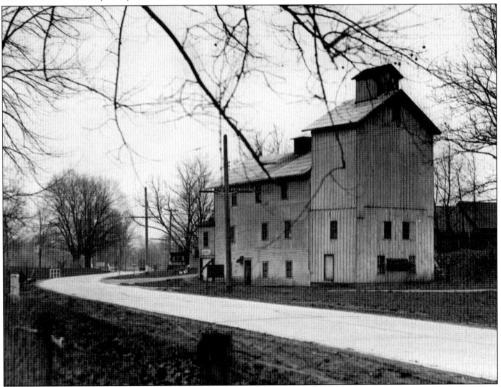

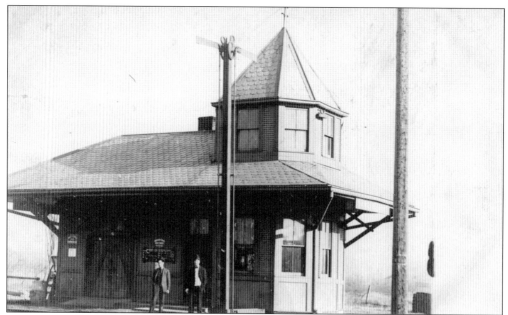

The train depot shown here in the early 20th century stood some 300 feet southeast of the corner of Prospect Road and Westwood Drive in the Vigil area of Strongsville. It served the Baltimore and Ohio Railroad, which was constructed through the township in 1889 and is still in use today. The depot was razed in 1951.

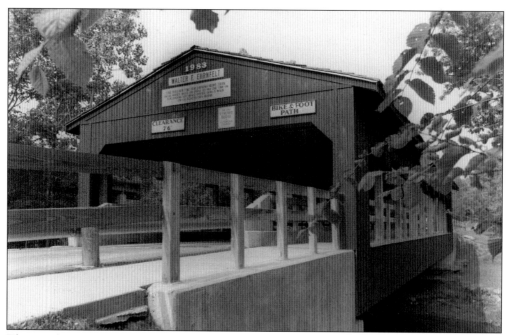

This one-lane bridge was the only covered bridge in Cuyahoga County when it was dedicated in 1983 as a tribute to Mayor Walter F. Ehrnfelt. It crosses the east branch of the Rocky River on Whitney Road, west of Big Creek Parkway. At the time of its construction, it was believed to be the first covered bridge built in Ohio in more than a century.

*Three*

# STRONGSVILLE THEN AND NOW

From its beginnings in 1816 through the Civil War, the Industrial Revolution, the Depression, two world wars, and on into the 1950s, Strongsville maintained a steadily growing population remaining under 8,000. It was at approximately 8,500 by the time it became a city in 1961 and finally reached 10,000 later that decade. By the late 1970s, the number of residents had more than doubled to around 22,000, and by the end of the 20th century, that figure had doubled again.

Over nearly two centuries, the transformation from township to village to city has been obvious. The secondary dirt roads and brick streets are long gone, as is most of the farmland. The quiet, tree-lined Wooster Pike has become the city's main thoroughfare, Pearl Road, with its countless businesses and restaurants. The additions of Interstate 80 (Ohio Turnpike) in 1955 and Interstate 71 in 1965 have spurred further growth and expansion of new homes and places of business. Today the number of both residents and businesses continues to increase.

Beyond all the development and revitalization, reminders of Strongsville's past are everywhere. Many of the historic buildings remain, and the city's main streets have stood the test of time. Some of the changes that have taken place over the years and decades have been significant, while others have been more subtle. In either case, even the casual observer can usually discover some vestige of the way things once were. In the following pages are some examples of these changes over time.

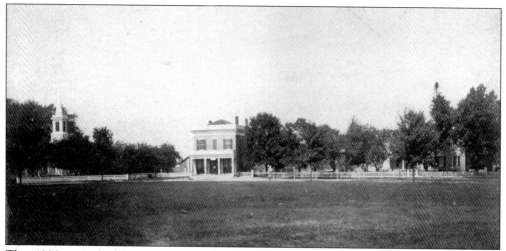

This 1900 view, looking west across the commons, shows Alanson Pomeroy's three major architectural contributions to Strongsville: the Congregational Church, built in 1853 (left); the Pomeroy General Store, built in 1850 (center); and the Homestead, built in 1848. Although Pomeroy also served as township trustee and justice of the peace, his primary business was the general store.

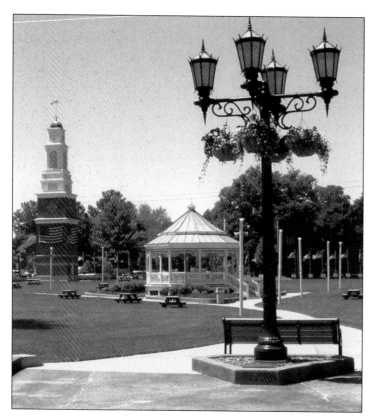

Today the same westward view includes the clock tower, which was built by the Strongsville City Club and dedicated in 1992. Despite its modern-era construction, the clock tower has become, along with some of the more historic city landmarks, an architectural symbol of Strongsville.

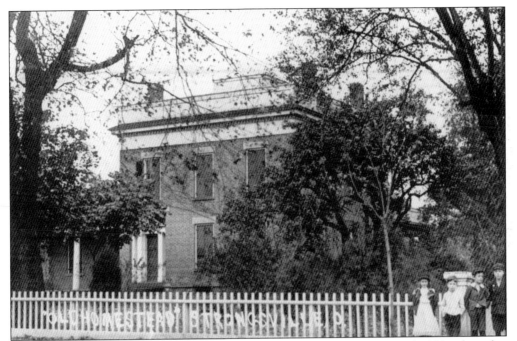

Alanson Pomeroy's original Homestead was still a family residence around 1920, when this photograph was taken. Dr. Harlan Pomeroy's daughter Gertrude left the house vacant when she moved out in 1963, and it quickly fell into disrepair.

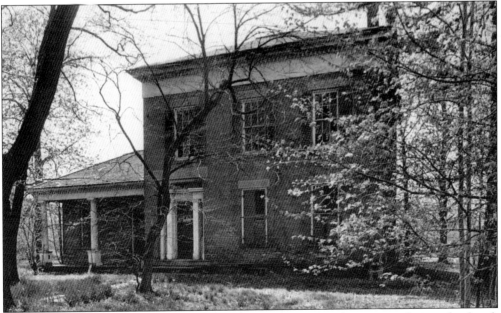

Many Pomeroy House admirers would be surprised to learn that this majestic historic landmark was an eyesore in Strongsville from the mid-1960s through the 1970s. In those years, the home was a target for vandals and, legend has it, a sanctuary for the "Pomeroy House Ghost." Despite its dilapidated condition, the residence was placed on the National Register of Historic Places in 1975, the year this photograph was taken. (CSU.)

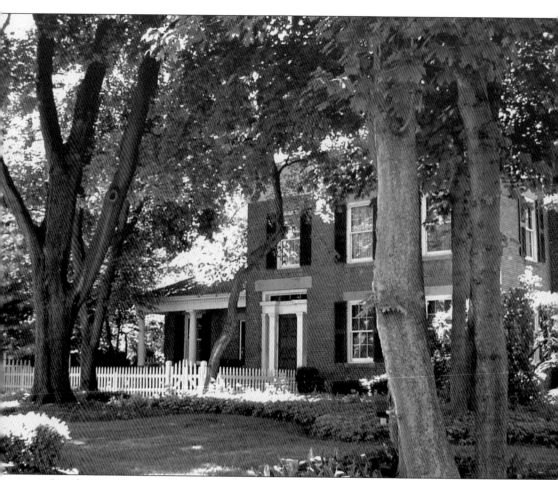

Local restaurateur Don Strang purchased the Pomeroy property in 1978 and began an extensive, detailed renovation. The original interior woodwork around the doors and windows was salvaged and restored. Many original trees on the property were also saved. Don's Pomeroy House Restaurant opened in 1980 and has retained the elegance and beauty of Alanson Pomeroy's Homestead. It is one of Strongsville's historical crown jewels.

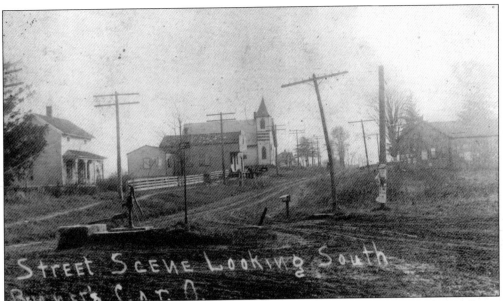

Bennett's Corners was one of several communities in Strongsville. This view shows what is now West 130th Street, looking south into Hinckley and Medina County. The Bennett's Corners Community Methodist Church, built in 1892, is the only structure still standing. The year is 1910.

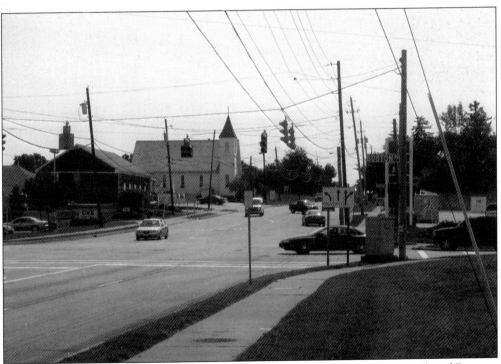

The city's southeastern corner, where Boston Road, West 130th Street, Hunt Road, and Bennett Road converge, is still often referred to as Bennett's Corners. (Amy Anter.)

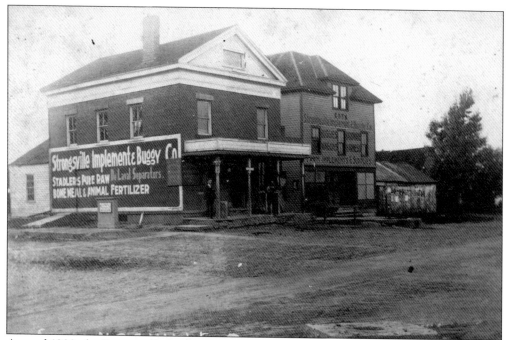

Around 1900, the Strongsville Implement and Buggy Company included the original structures built by Warner Strong and Lawrence Bedford at Wooster Pike (Pearl Road) and Depot Street (Westwood Drive). The roadways had not yet been modernized with brick pavement.

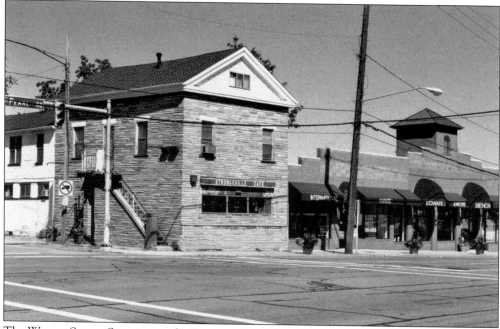

The Warner Strong Store is now the Strongsville Café, with a stone facade replacing the original brick. The Lawrence Bedford building was eventually torn down to accommodate the expansion of Pierce Motor Sales, which had for more than 30 years occupied the building that is now the Crossroads Market Plaza. (Amy Anter.)

In the early 1900s, the population of Strongsville was approximately 1,200, and the busiest thoroughfare in the township was a tranquil, tree-lined dirt road. The rear of a lone stagecoach can just barely be seen down the road in the distance.

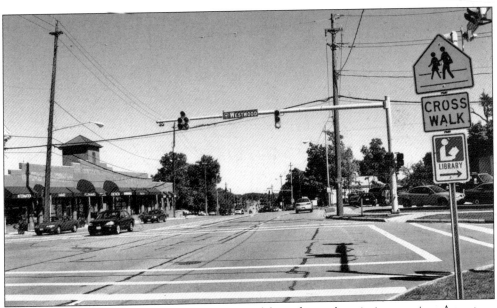

The same view in 2006 looks north on Pearl Road from the city's main intersection. A century earlier, the white commercial building to the right was the home of former mayor Grant Atkinson. (Amy Anter.)

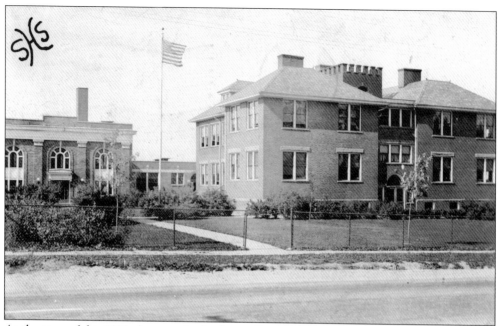

At the time of this 1931 photograph, the former Strongsville High School building at right was still in use as an elementary school. To the left is the gymnasium that was built in 1921, along with the larger high school facility behind this structure.

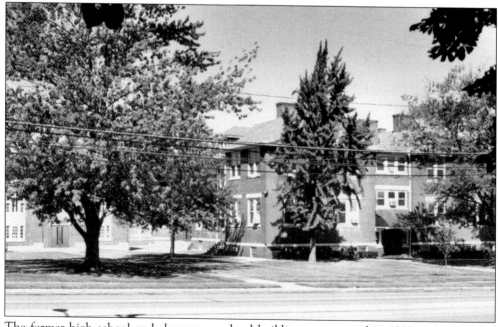

The former high school and elementary school building, constructed in 1908 and remodeled in 1916, is now headquarters for the Strongsville City Schools and the board of education. The original gymnasium is part of Center Middle School. (Amy Anter.)

Interstate 71, nearing completion above, was constructed in 1965 and literally transformed the driving habits of commuters to downtown Cleveland and travelers to Columbus and other parts south in Ohio. (CSU.)

The Interstate 71 and Route 82 intersection now accommodates thousands of vehicles on a daily basis. Multiple businesses, hotels, and the Westfield South Park Mall have emerged within a mile of this bustling area of the city. (Amy Anter.)

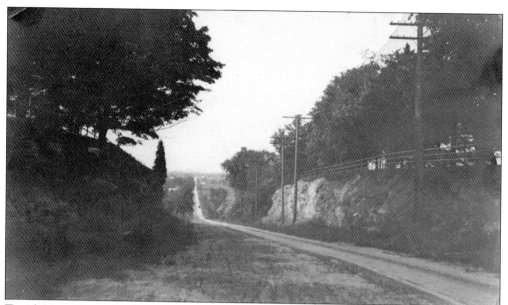

Traveling north on the Wooster Pike from Brunswick into Strongsville, the first stop is Stone Hill, just past Boston Road. The quarried stone from this area was used to build the Franklin Strong home, which is beyond the line of trees to the right. This photograph was taken in the early 1930s.

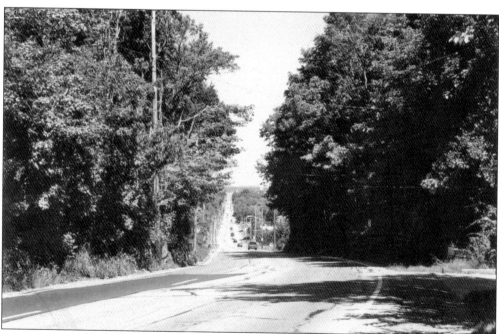

From the top of Stone Hill today, a panoramic view of the center of Strongsville is possible, including the clock tower and the water tower. The control tower of Cleveland Hopkins International Airport can be seen eight miles away on the horizon. While traveling down the hill on a clear day, one may momentarily glimpse the downtown Cleveland skyline in the distance to the right. (Amy Anter.)

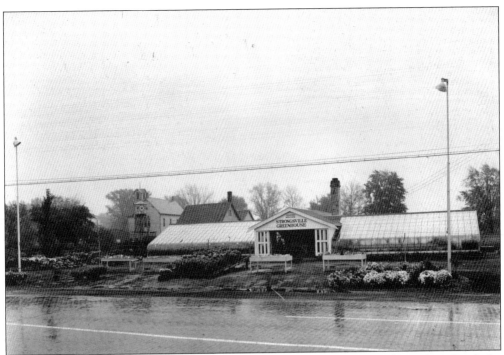

The Hirt family owned the flower and greenhouse business at Pearl and Royalton Roads for approximately 90 years. This 1940 image offers a clear view of Pearl Road as it existed for several decades, paved in red brick. (Alan Hirt.)

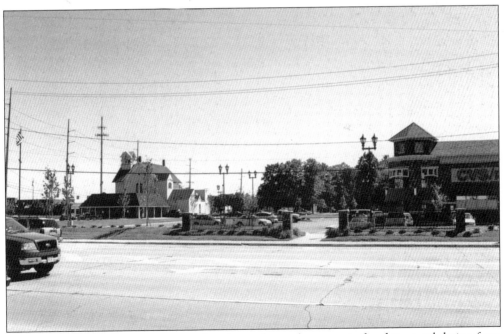

A modern view of the same intersection shows the stark contrast of architectural design from the 1879 Old Town Hall to the 2006 pharmacy. The city hall and police facility is visible to the left. (Amy Anter.)

The commons was known to residents as Strongsville Park when this photograph was taken in the 1940s. While visitors have always been greeted in Strongsville, the welcome sign shown here has long since been removed.

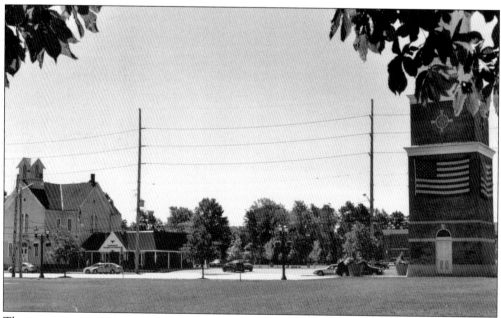

The same view in 2006 reveals the Strongsville Chamber of Commerce next to the Old Town Hall. The clock tower is now the most prominent "welcome" on the commons. (Amy Anter.)

# Four

# GOVERNMENT AND BUSINESS

From its organization as a township in 1818 to its incorporation as a village 109 years later, Strongsville maintained a government consisting of three township trustees, a clerk, a constable, and a game warden (all elected). In the November 1927 election, a township of approximately 1,300 voted to become a village. A special election was held a few days later, and a mayor and six councilmen were elected. Despite its newfound status as a village, Strongsville did not adopt a charter for its self-government until 1959.

The chief law enforcement officer for the township was an elected constable and, after the township became a village, a marshal. In 1930, Strongsville's police force included a marshal and three deputies. Officers on duty provided their own vehicles. As population increased in the 1940s, the city obtained two police cars and increased the number of officers. By the mid-1960s, there were 13 officers and five vehicles. Some 40 years later, the police department has grown to 76 officers protecting the city. The fire department began as a group of township volunteers known as the Minute Men. It became a full-time unit in 1971 and operates today from four fire stations throughout the municipality.

Strongsville has adhered to a master plan developed in the 1960s, and the growth of the city's industrial parks has continuously broadened its tax base. While emphasizing new business as well as the expansion of existing companies, Strongsville strives to maintain a balance between its residential, commercial, and industrial development. Where a shopping excursion once meant a trip to the local feed store, today the Westfield South Park Mall is just the beginning of an endless array of retail choices. The major companies coexist with the smaller shops, stores, and businesses, some of which have become household names to residents. A cursory review of the chamber of commerce membership directory reveals the extent to which business in Strongsville—large and small—has grown and expanded from the days of farms, mills, and general stores.

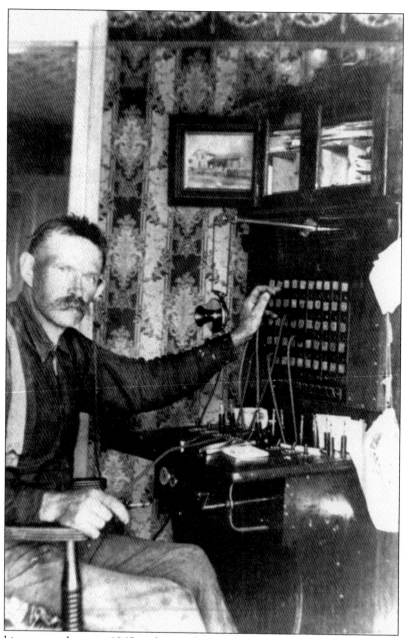

Grant Atkinson was born in 1865 and moved to Strongsville with his wife in 1889. He ran a cheese factory from his Shurmer Road home and established Strongsville's telephone system, which he is shown operating in this photograph. In 1904, he purchased a home on Pearl Road that still stands just north of the commons. He was employed with Pierce and Graves butchers (later the R. D. Graves Company) and eventually became a director of the Berea Radio and Supply Company. He served as justice of the peace for 23 years and as township magistrate. Helping to organize the township as a village, Atkinson was elected Strongsville's first mayor in 1927, at a salary of $250 per year. He later chose not to seek a second term. As mayor of a farming community of 1,300, he often had to address issues of cockfighting and chicken thievery. Atkinson lived in Strongsville for 47 years and died in 1936.

From 1928 to 1955, Leonard O. Bean ("Beanie" to student passengers) owned Strongsville's private school bus company before selling it to the school board. He was the first president of the chamber of commerce. Under Bean's leadership as the village's second mayor (1930–1941), 38 miles of secondary dirt roads were paved and voter registration more than tripled. He died in 1958 as chief radio administrator for the Ohio Turnpike Commission.

J. Albert Frank served as treasurer of the township for 12 years before becoming mayor in 1942. He was influential in establishing Strongsville's library and its chamber of commerce. He died in office in 1944.

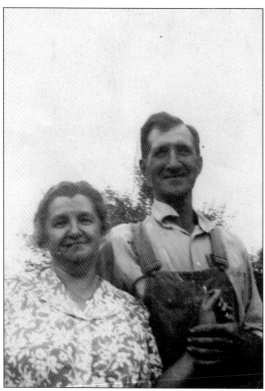

In 1944, after three years on the village council, Norris Crumpler (shown with his wife, Gladys) took over as mayor upon the death of J. Albert Frank, serving until 1951. During his term, the police department became full-time and additional traffic lights and streetlights, sidewalks, and water mains emerged. A new town hall was also constructed under his leadership and dedicated in the spring of 1952. He died in 1971 at age 89.

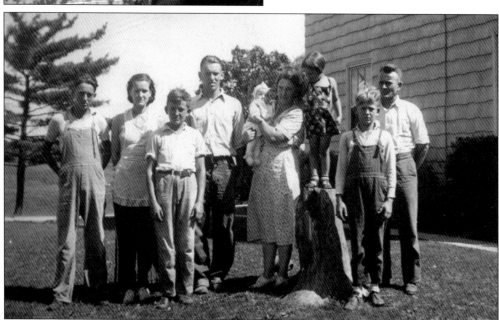

E. A. "Ben" Sprague served as mayor during a period of rapid residential and industrial growth and the construction of the Ohio Turnpike in the 1950s. Pictured here, from left to right, are Clyde, Faith, Calvin, Lee, Inez (holding daughter Janet), Ruth, Ben Jr., and Ben Sprague. Sprague Road was named for Ben's grandfather David, an early settler of what is now North Royalton. (Lee Sprague.)

William L. Tomson's law enforcement career began when he became deputy marshal in 1930. He eventually attained the rank of captain in the Strongsville Police Department before being appointed building commissioner in 1951. In 1955, Tomson was elected Strongsville's first full-time mayor and held the office until 1967. During his term, the village population more than doubled, and Strongsville became a city in 1961. Tomson died in 1988 at age 83.

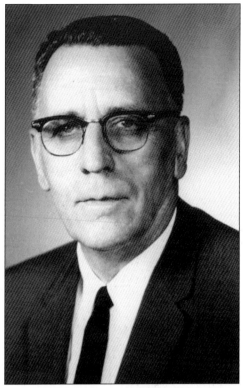

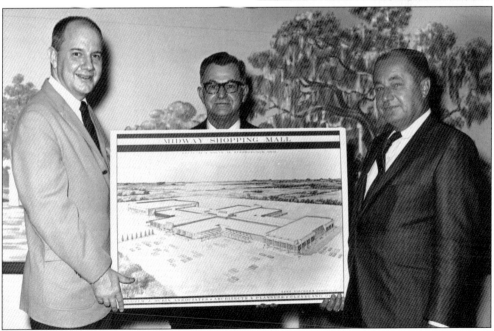

Developer R. A. Gall (right) shows William Behr (left) a proposed shopping center project at Pearl and Royalton Roads; the project never went forward. Almost immediately after he took office as mayor in 1968, Behr clashed with council members over a variety of issues. In December of that same year, he became the first mayor in Ohio to lose his office in a recall election. (CSU.)

Dale Finley traces his Strongsville family roots to 1852. Elected to city council in 1965, he was council president when William Behr was recalled in 1968. The youngest ever to become Strongsville mayor at age 33, Finley immediately began efforts to heal what had become a tumultuous community. Under his leadership, the city's volunteer fire department became full-time with an ambulance program, and a new fire station and library were built. The city's first master plan was created, and property was purchased for parkland, for the city service center, and for the baseball and soccer fields on Foltz Industrial Parkway. A senior citizen program was created, and a citywide trash collection program was implemented. Finley resigned as mayor in 1974 to become executive director of Northern Ohio Urban Systems, a land-use research corporation that helped create the Cuyahoga Valley National Park. He later served as executive director of the Greater Cleveland Convention and Visitors Bureau, and as chairman of the board of Cleveland's Regional Transit Authority. A lifelong Strongsville resident, Finley retired in 1994. (Dale Finley.)

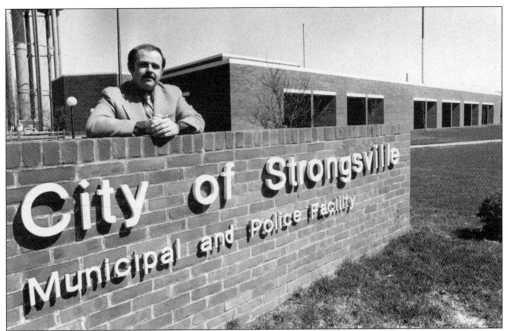

Council president John P. Pearce was appointed mayor in 1974 when Dale Finley stepped down. He is shown here in front of the newly renovated and expanded city hall and police facility, completed during his term. Pearce announced his resignation as mayor at a council meeting on March 20, 1978. (CSU.)

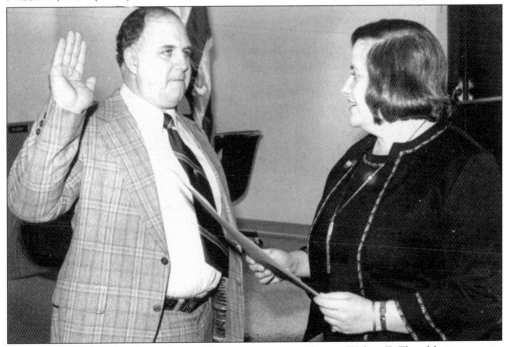

Only four months after first taking office as a city councilman, Walter F. Ehrnfelt is sworn in as Strongsville mayor on May 1, 1978. Administering the oath of office is U.S. congresswoman Mary Rose Oakar.

A city resident since 1945, Walter F. Ehrnfelt starred in football, basketball, and track in the Strongsville High School class of 1951. After graduation, he went to work in the family meat business, which has been in continuous operation at Cleveland's West Side Market since 1912. His political career did not begin until he won a school board seat in 1973 against an incumbent member who was leading a fight to ban books and dismiss teachers. Ehrnfelt was elected to city council in 1977 and took office in January 1978. In May, he was appointed mayor upon John P. Pearce's resignation. Under Mayor Ehrnfelt's management, Strongsville transformed from a community of approximately 22,000 to a thriving suburb of 45,000. Reelected six times, his 25-year term came to an untimely end with his death in May 2003 at age 70. The city's covered bridge, the Recreation and Senior Center, the soccer complex, and (by act of Congress), the local U.S. post office all bear his name, which has long been synonymous with Strongsville. (Anne Ehrnfelt.)

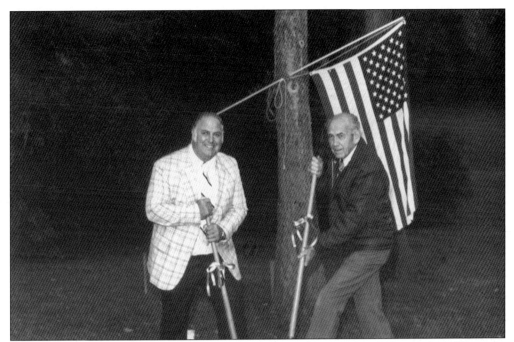

Walter F. Ehrnfelt (left) and Howard Chapman, shown above in the 1980s, combined for more than 80 years of service to the Strongsville community. Chapman was already well into his teaching career when Ehrnfelt was born in 1932.

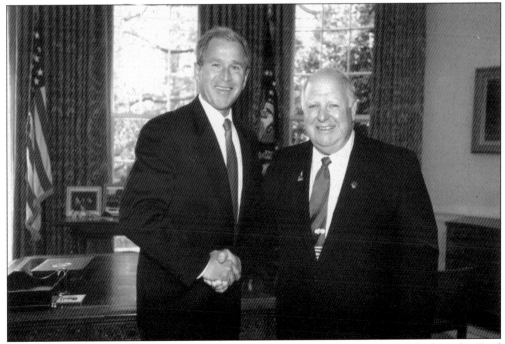

One of Mayor Ehrnfelt's proudest moments was meeting with Pres. George W. Bush in the Oval Office in 2001. During the 2000 campaign, the president had promised the mayor he would invite him to the White House if Ehrnfelt helped Bush win in Ohio. (Anne Ehrnfelt.)

Upon Mayor Walter F. Ehrnfelt's death in May 2003, council president Raymond L. Haseley took over as acting mayor pursuant to the city charter and served in that capacity for the remainder of that year. In January 2004, city council passed a resolution expressing appreciation to Haseley for his service during that time.

Thomas P. Perciak was elected Strongsville's 12th mayor as a write-in candidate and took office in January 2004. A longtime active member and former president of the chamber of commerce, he had joined Strongsville Savings Bank as managing officer in 1979 and eventually became its president and CEO. He retired as executive vice president of Fifth Third Bank when he was elected mayor. (Office of Mayor Perciak.)

Born in 1884 in Newmarket, North Wales, Edward Blythin immigrated to America in 1906. He attended law school in Cleveland and was admitted to the Ohio bar in 1916. He and his wife, Jane, moved to Strongsville in 1922, and he was instrumental in incorporating the township as a village in 1927. A new mayor and council were elected, and Blythin was appointed law director. He served in that capacity for many years in Strongsville and other communities, while also serving as a member of the Strongsville Board of Education. He and his family moved to Cleveland a year after being named that city's assistant law director in 1935. He was appointed Cleveland mayor in 1940 when then-mayor Harold Burton was elected to the U.S. Senate. Blythin lost his own bid for election as mayor in 1941, returned to private law practice, and was elected a Cuyahoga County Common Pleas judge in 1948. In 1954, he presided as judge over the infamous murder trial of Dr. Sam Sheppard. Blythin died in 1958 during his second term of office.

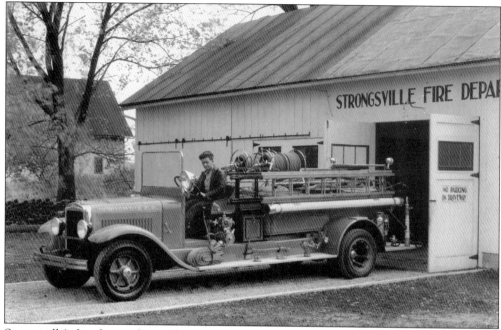

Strongsville's first fire truck was this International model with a 500-gallon tank and a midship pump. It was purchased in 1931, the year this photograph was taken. At that time, the fire department was a 15-member volunteer unit, and the station was located just to the east of the Old Town Hall. Pictured on the truck is Lawrence Hirt, the village's first fire chief. (Alan Hirt.)

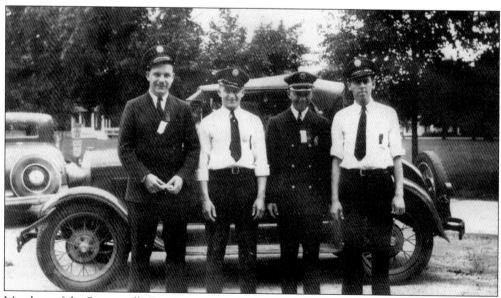

Members of the Strongsville Fire Department in 1935 include, from left to right, Herb Speck, Roy Finley (father of future mayor Dale Finley), Chief Lawrence Hirt, and R. Pierce. (Alan Hirt.)

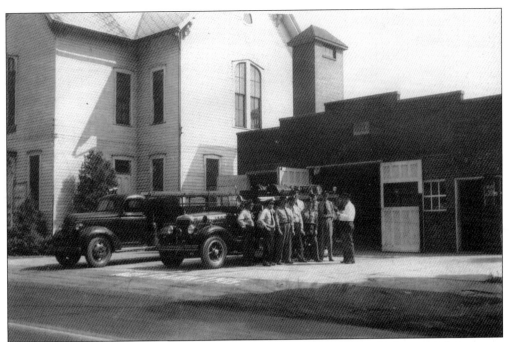

Strongsville's fire station stood next to the town hall until a new facility and department headquarters were built in the early 1970s just across Royalton Road. This photograph was taken in the 1940s. The 1931 fire truck shown here was finally replaced in 1948. (Alan Hirt.)

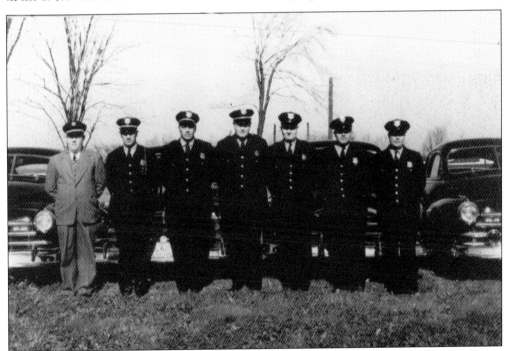

Posing in this 1948 photograph are, from left to right, Strongsville fire chief Charles Graves and police officers Charles Sperber, William L. Tomson (future mayor), Chief Robert Poots (great-grandson of John Poots), Myron Hackley, Clifford Peebles, and Lloyd Killian.

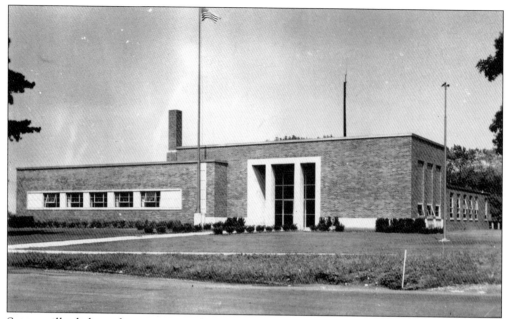
Strongsville dedicated its new town hall in 1952. It replaced the Old Town Hall, which had served as municipal headquarters for 73 years.

The current city hall and police facility was completed in 1975. Today the building houses the police department, council chambers, and the mayor's court. The city's administrative offices, including the mayor's office, are located in the Strongsville Service Center on Foltz Industrial Parkway. (Amy Anter.)

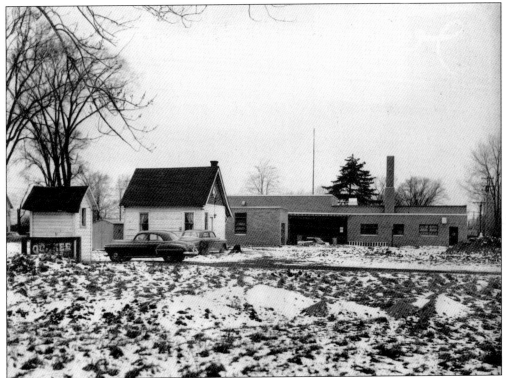

This 1952 view from behind the newly constructed town hall shows the tiny cottagelike structure that at that time was Cuyahoga County's smallest library. It had once served as housing for the Roof mansion's electrical system. The library moved into a room in the new town hall building but was later relocated to a renovated Old Town Hall in 1963. A new library was completed in 1971. (CSU.)

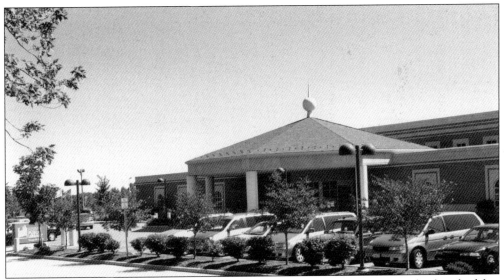

Strongsville's 35,000-square-foot library building was completed in 2003, just a few hundred feet from where the county's smallest library had stood a half century earlier. (Amy Anter.)

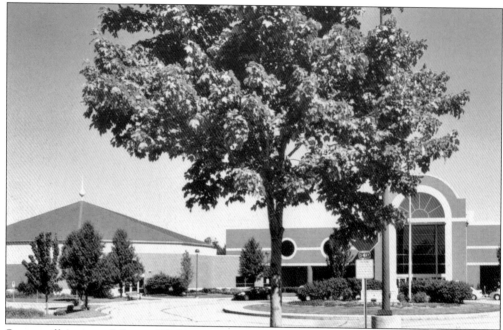

Strongsville's state-of-the-art 157,000-square-foot Recreation and Senior Center was dedicated in March 1998. By resolution of city council, it was renamed in honor of Mayor Walter F. Ehrnfelt within several days of his passing in 2003. Its aquatics center was named by USA Today as one of the top 10 community pool facilities in the country in 2001. (Amy Anter.)

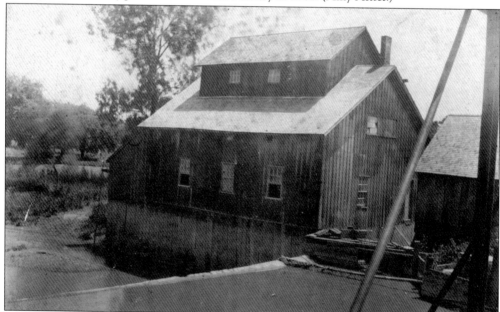

In Strongsville's earliest days, residents had to grind their grain at Vaughn's Mills in Middleburg Township or Hoadley's Mills in Columbia. John Stoughton Strong saw the need for a mill in Strongsville and, in 1820, built this facility, shown from the adjacent bridge. A sawmill and distillery were later built nearby. Some of the first workers included Elijah Lyman, Ansel Pope, and Thaddeus Lathrop.

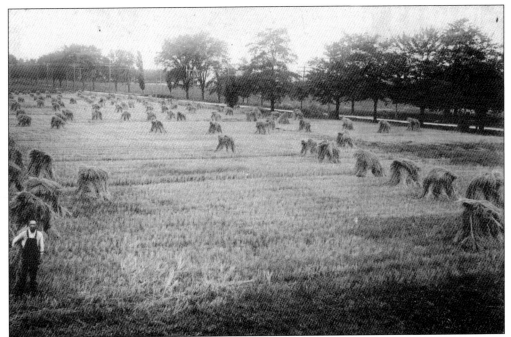

After selling his Howe Road property to Albert Bedford in the 1880s, Richard Gibbons purchased this farm. Looking south from the center of town, this view shows the old Wooster Pike to the right. The Pearl Road retail business district south of Royalton Road now occupies this area.

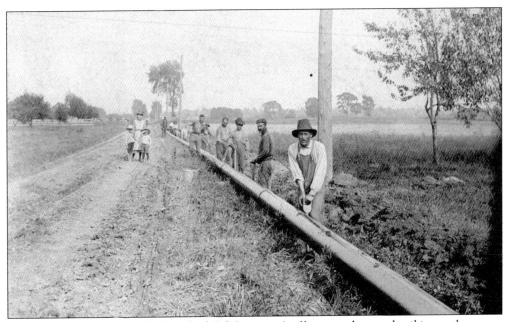

Formed in 1886 as part of the Standard Oil Company's effort to gather crude oil in northwestern Ohio, the Buckeye Pipe Line Company operated a pumping station on Boston Road at Prospect Road in Beebetown. Buckeye later became one of the country's largest independent carrier pipelines. Here workers lay Buckeye's massive pipeline along the southern side of Boston Road in the late 1880s.

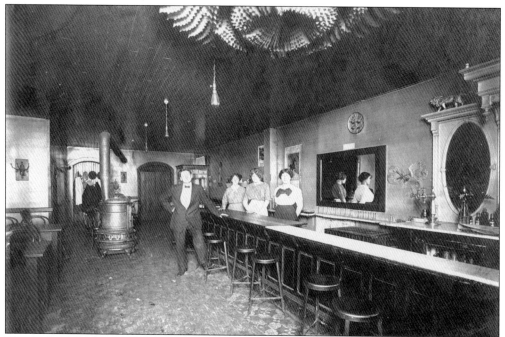

This early-20th-century view of the interior of a local tavern typifies the atmosphere and decor of the day in these establishments.

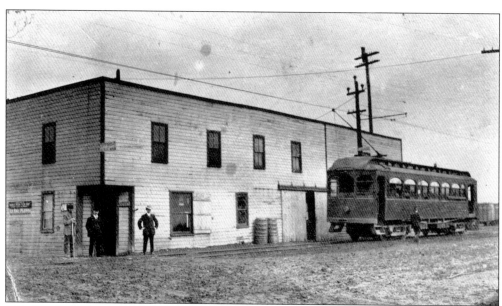

John Roy built this general store at Prospect Road and Westwood Drive (formally Depot Street) in 1896. Ernest and Frederick Fish purchased it in 1900, followed by brothers Frank and Joseph Siedel in 1905. Siedel's General Store sold all types of food, merchandise, and farm implements. As seen above, it stood only a few steps from the Cleveland Southwestern Interurban Railway, which ran along Prospect Road from 1903 to 1931.

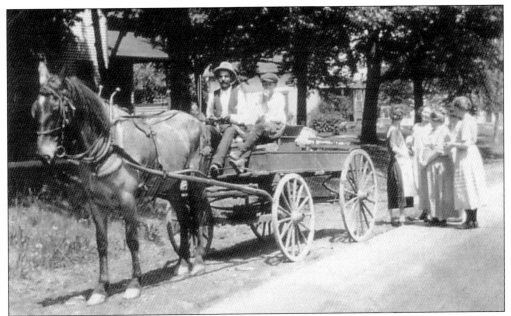

Samuel Hirt is seen at left soon after he settled in Strongsville in 1915. He purchased the property at Royalton and Pearl Roads and constructed a greenhouse for growing flowers and vegetables. That business, Hirt's Greenhouse and Flowers, remained at Strongsville's main intersection until 2005, at which time Hirt's opened a flower shop on Pearl Road and relocated the garden store and greenhouse to Medina. (Alan Hirt.)

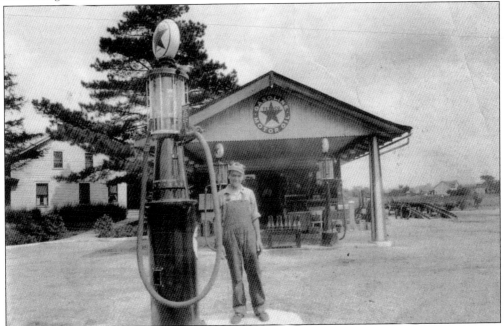

The Hirt family operated a Texaco station at the same Pearl and Royalton intersection, shown here in 1928. For many years, it was one of the busiest such facilities in Ohio due to its proximity to the Wooster Pike, the main road leading to Columbus. Interstate 71 would not be constructed for another 37 years. (Alan Hirt.)

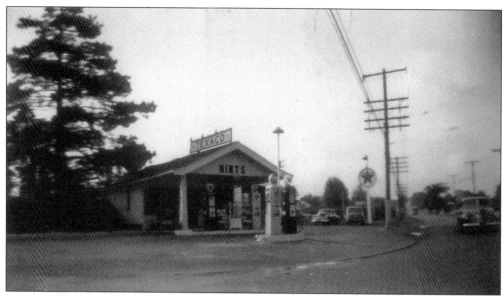

The same Texaco station is shown in this 1940s view, looking south down Pearl Road. (Alan Hirt.)

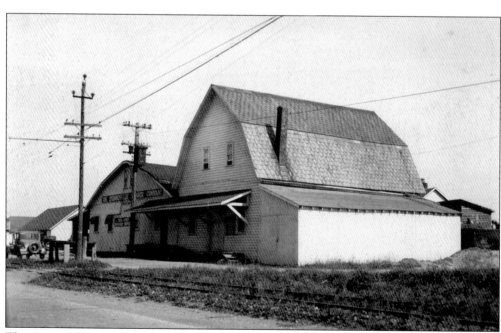

The Strongsville Lumber Company was located at the intersection of Prospect Road and Westwood Drive at the time of this 1930s photograph. It was not uncommon in Strongsville and other rural communities to convert old barns for business use.

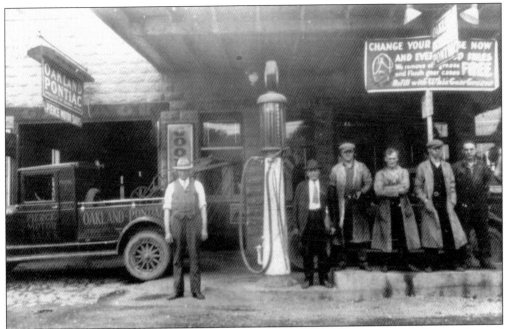

Leonard O. Bean sold his Pearl Road service garage to Roy Pierce in 1927. Pierce, pictured at left in 1928, became a Pontiac dealer and, five years later, a Dodge-Plymouth dealer. The only dealership in Strongsville, Pierce Motor Sales operated until it was sold in 1961 following Pierce's death. The franchise eventually became known as Kilbane Dodge.

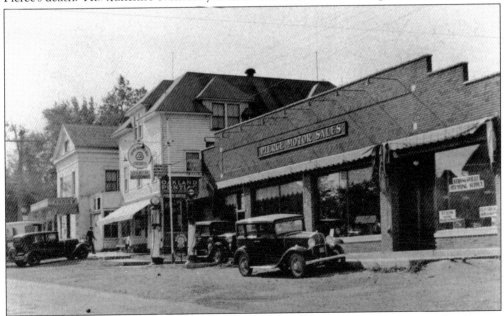

This photograph was taken in the late 1920s, when Pierce Motor Sales was still a Pontiac dealership. The Pierce facility was expanded several times. To the left of the property is the building that originally housed the Bedford-Howe Hardware Store and later Burnham's Cash Store. Adjacent to it is the general store that became the Strongsville Café. Pearl Road was a narrow two-lane street at this time.

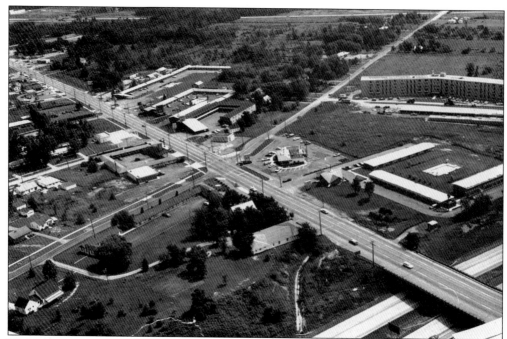

With the construction of the new Ohio Turnpike through Strongsville in 1955, the motel business grew rapidly on Pearl Road in the city's north end. Above is a 1969 aerial view of Pearl and Whitney Roads in which at least seven motels are visible. The turnpike can be seen in the lower right corner. Below is a 1974 scene of the same area, showing four consecutive motels on Pearl Road. Several more motels stood within one square mile. A few of these establishments still remain, while many others have been torn down to accommodate expanding retail development. (CSU.)

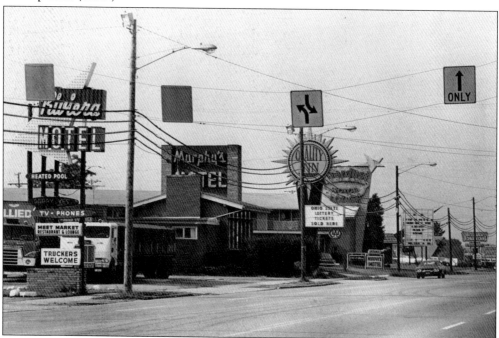

This 1950s aerial view shows the delicatessen that stood on Pearl Road across from the Strongsville Café and adjacent to the Strong House, which can be seen to the upper right. The building was razed in 1960.

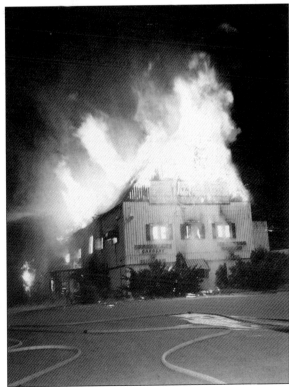

Another example of a converted barn was the Colonial Gardens Tavern, located at 8835 Pearl Road just north of Whitney Road. Forcing the evacuation of 100 guests at the adjacent Murphy's Motel, this September 1961 fire destroyed the tavern. (CSU.)

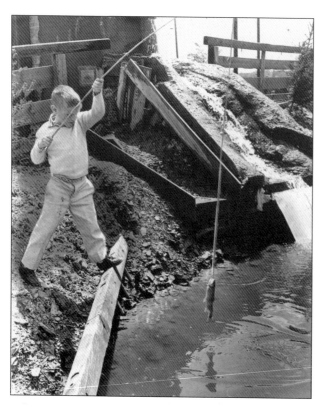

Trout Park was a series of unique artificial fishing ponds opened in the early 1960s at 18052 Pearl Road. The fenced-in ponds were stocked with trout, carp, bluegills, catfish, and bass. In this 1963 photograph, a five-year-old fisherman has just caught his first speckled trout. (CSU.)

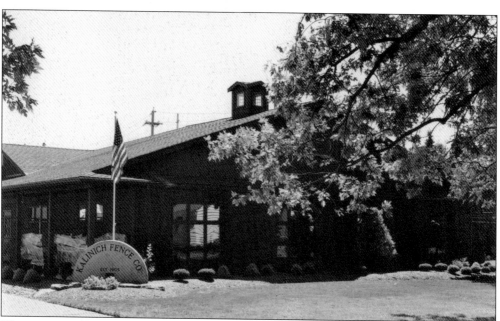

The nation's oldest snow fence manufacturer in continuous operation, the Kalinich Fence Company has conducted business from its Prospect Road location since 1956. It now distributes fence products worldwide from its Strongsville headquarters and its plants in Michigan and Texas. (Amy Anter.)

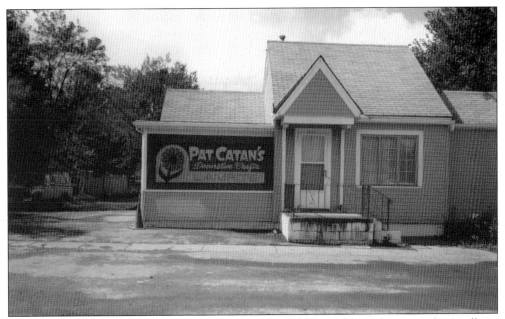

Pat Catan opened a craft store in Cleveland in 1954 and moved his business to Strongsville in 1965. Today the Pat Catan's Craft Center chain has 19 locations in Ohio and Pennsylvania, and the business has also evolved into Darice, a crafts wholesaler distributing to stores nationwide. Catan Fashions, a 54,000-square-foot bridal salon, one of the largest of its kind in the country, now occupies the location above. (Mike Catan.)

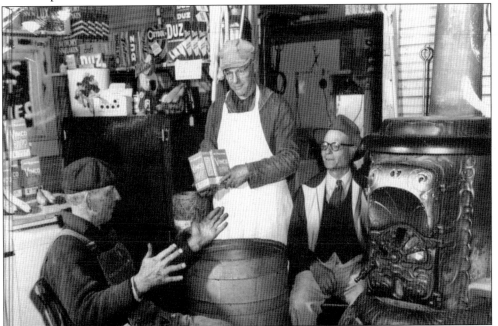

Harley Fuller lived in the homestead built by his great-grandfather in 1827 on Marks Road in Beebetown. He was no doubt a regular customer at the Olds General Store. Harley is pictured at left with Mort Olds (center) and with his brother M. P. Fuller. The store was a popular meeting place for Olds and his Beebetown neighbors.

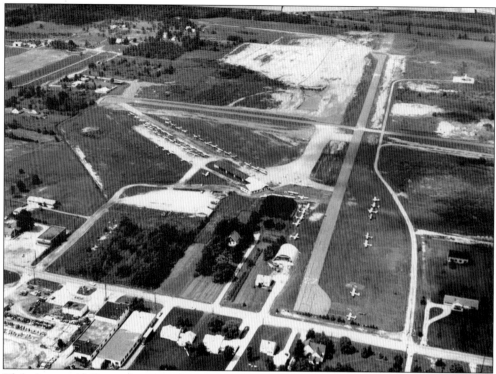

This August 1969 aerial image shows the Strongsville Airpark, which was located west of Prospect Road and north of Westwood Drive. The tiny airport opened in the 1950s and by the early 1960s had two operating runways. It closed in 1987, and the Westwood Farms residential subdivision now takes up most of the site. (CSU.)

The city's first industrial park opened in 1966, and there are now four industrial parks comprising nearly 200 businesses on over 2,000 acres of land. The largest of the four is the Strongsville Business and Technology Park, which contains 65 companies employing approximately 2,800 people. (Amy Anter.)

*Five*

# LIFE AT THE CROSSROADS

Strongsville's eclectic mix of places of worship reflects the diversity of its people. The city includes two Baptist, two Roman Catholic, one Episcopal, one Evangelical, three Lutheran, one Methodist, one Congregational, one missionary, and three nondenominational churches. Some of these churches date back to the 19th century.

Strongsville's schools regularly receive Ohio's highest academic ratings. For many years, its students attended grades kindergarten through 6 in elementary school and grades 7 through 12 in high school. When the current high school facility opened in 1964, the previous building became Strongsville Junior High School with grades seven through nine. It was renamed Center Junior High when Albion Junior High opened in 1970. The district now includes the high school, Center and Albion Middle Schools (seventh and eighth grades), and eight elementary schools. The recreation programs offer opportunities to children from a young age in a variety of sports. That has resulted in a highly successful high school athletic program, including (since 1997) state championships in boys and girls soccer and in baseball.

The city has become an attractive choice for homeowners because of its convenient location, wide range of housing choices, school system, park and recreation facilities, and services. Housing starts in Strongsville are usually among the highest in Cuyahoga County. Many of Cleveland's professional athletes reside in the city. Young couples looking for the right community to raise their children find their home here. People who can trace their lineage in Strongsville to the 1800s would not dream of living anywhere else.

Sometime after Interstate 71 was completed in the 1960s, Strongsville adopted a motto identifying itself as the "Crossroads of the Nation" due to its location at the crossing of two major interstate highways. That motto has endured as the city has grown and prospered. For most who choose to live here, there exists a communal sense of pride and belonging. It is felt when cheering on the Mustangs at a high school game, when converging on the commons for the annual homecoming, or when walking among the Christmas lights in the Strongsville Historical Village.

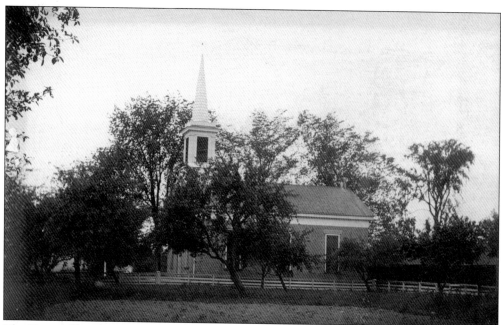

The United Church of Christ (Congregational) was first established in Strongsville's infancy in 1817. Some of the township's earliest settlers were members, including Guilford Whitney and his wife, Anna. The present church building at Pearl and Royalton Roads was dedicated in 1853 and retains much of its original appearance (as seen above) despite several additions. At the time of the church's dedication, one of its prominent members was Alanson Pomeroy.

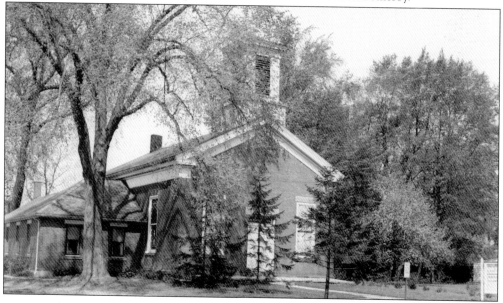

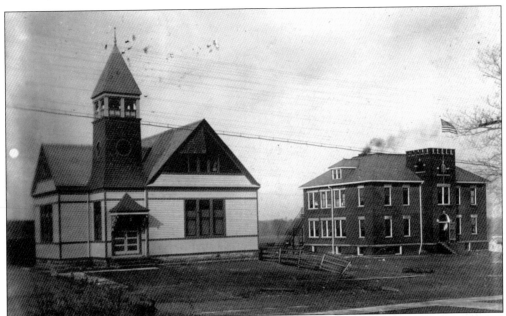

The United Methodist Church began in Strongsville in 1819. Originally located on the southwest corner of Pearl and Royalton Roads, it later moved to Albion. The wood-frame structure shown in 1909 adjacent to the high school was built on Wooster Pike (Pearl Road) in 1895. It was replaced at that site with the present facility in 1962. A new church is planned at Webster and Royalton Roads.

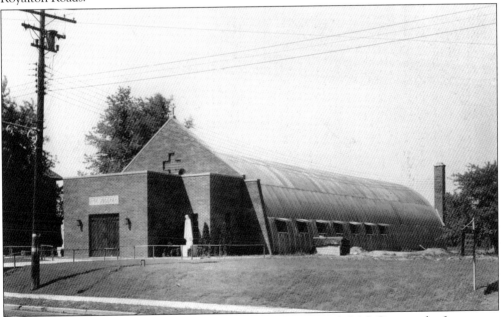

St. Joseph Catholic Church was founded in 1946, with Fr. Joseph J. McGraw as the first pastor. The Quonset hut shown above was completed later that year and served as the church for the next 19 years. Ground was broken on a new church in March 1964, and that building was nearly completed when a tornado destroyed the Quonset hut on Palm Sunday in 1965. (St. Joseph Church.)

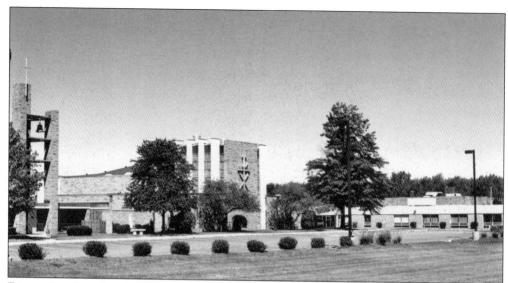

For two Sundays after the Palm Sunday tornado ravaged the original facility, St. Joseph Catholic Church held masses at Strongsville High School. The first mass was celebrated at the new church on May 1, 1965. That building, shown above, is still in use and now includes the Holy Family Center, completed in 1996. The SS. Joseph and John Interparochial School is seen on the right. A second Catholic parish, St. John Neumann, opened in Strongsville in 1977 with founding pastor Fr. Frank LaRocca, and the SS. Joseph and John school has served the families of both parishes since that time. St. John Neumann celebrated its masses at the high school auditorium until the building below was dedicated on July 4, 1982. (Amy Anter.)

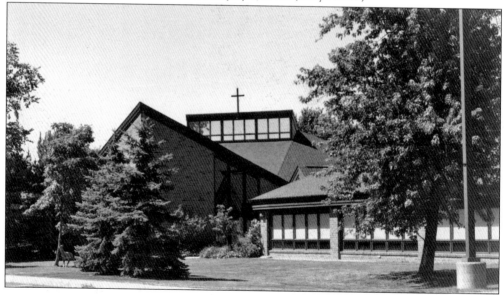

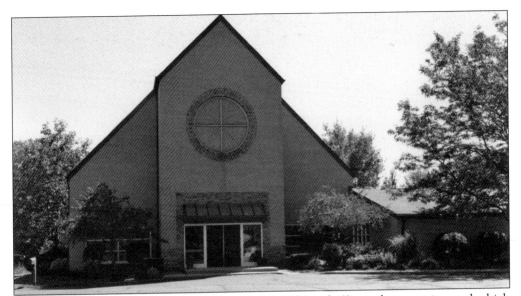

The First Evangelical Lutheran Church opened in 1956 with 69 members meeting at the high school auditorium. It has long been located at its current site on Royalton Road, just west of Pearl Road. (Amy Anter.)

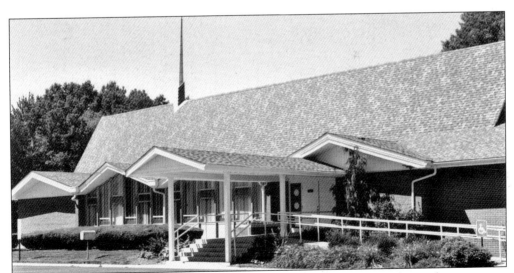

St. John Evangelical Lutheran Church was established in Berea in 1890 and moved to its present location at Prospect and Fair Roads in the northwest area of Strongsville in 1960. (Amy Anter.)

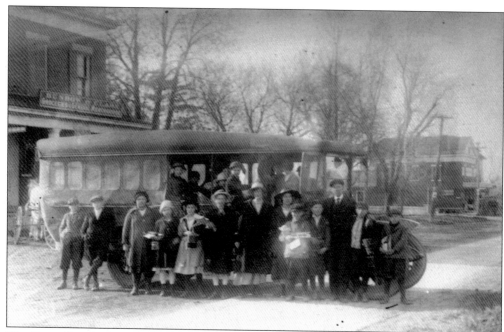

The Green Line bus service helped transport Strongsville children to school in the early 1900s, as shown above. The Benbow and Clark General Store can be seen on the left, next to the Pomeroy House, and the general store that later became the Strongsville Café is visible in the background. Below is a Strongsville school bus in the 1920s, around the time Leonard O. Bean took control of the private company that would operate the school bus system for 33 years.

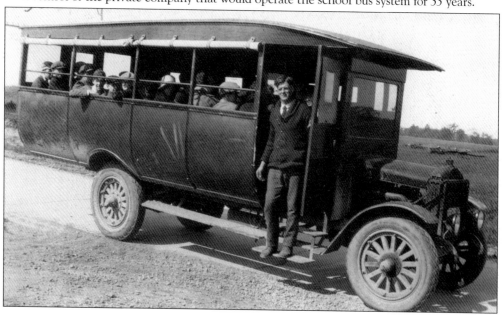

Elmer Drake, pictured here around 1900, was born in 1863. He was the eldest child of Dexter King Drake, whose uncle Asa Drake settled in Strongsville in 1820. He began teaching at age 16 in Strongsville's one-room district schools and eventually was named superintendent of schools in 1906. In addition to supervising each of the district elementary schools, he was the sole teacher of 12 different subjects for the Strongsville High School student body. His annual salary was $600. The district schools were in session Tuesday through Saturday so that Drake could take his Saturday off-day to visit the one-room schools. He designed programs and curriculums to stress the importance of education to students and parents, and the schools flourished under his leadership. He oversaw the construction of a new high school building in 1908 and its remodeling in 1916. He also began the process of centralizing the district schools, and all the one-room schoolhouses were closed by 1923. Drake moved on to Brunswick as superintendent in 1917 and retired in 1923. He died in 1937.

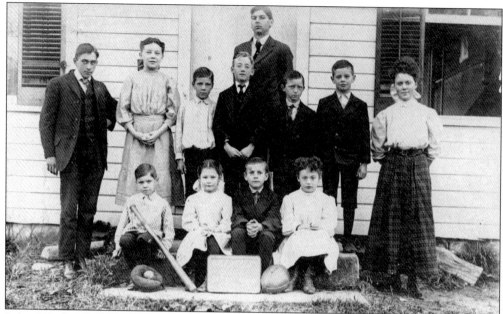

Leland Drake, the eldest son of Elmer Drake, graduated from Strongsville High School in 1907. He began his 50-year teaching career at the one-room District No. 7 Slab Hollow Schoolhouse on old Howe Road, shown here. He also served as principal in Berea and Columbus and as superintendent in Chagrin Falls. The Club of Russian Boys at Cleveland's St. Theodosius Church later purchased the school for use as a clubhouse.

The schoolhouse on old Howe Road later became the home of Strongsville's Creative Arts League. After construction of Interstate 71 in 1965, old Howe Road on the east side of the highway became a dead-end street, Mill Hollow Lane. On the west side of Interstate 71, a portion of Howe was renamed Tracy Lane and the remaining section of Howe Road was rerouted to where it now ends at State Route 82.

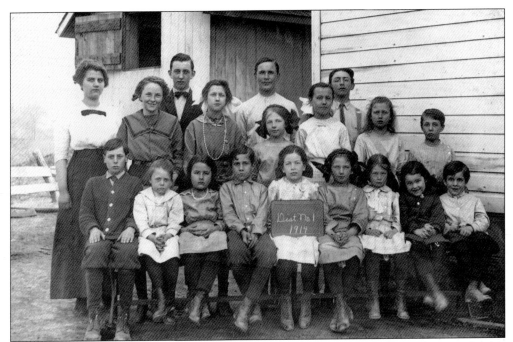

The District No. 1 Ashley Schoolhouse was located in Albion, where the students sat for this photograph in 1914. As seen here, children of many different ages and grade levels learned together in the same room.

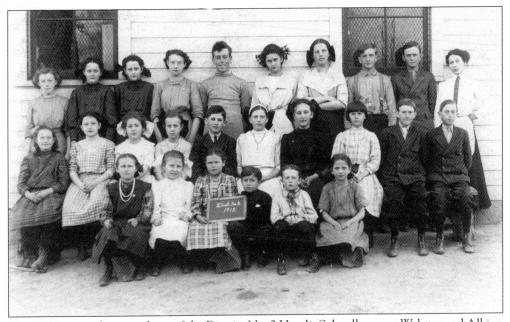

This 1913 image shows students of the District No. 2 Heazlit Schoolhouse at Webster and Albion Roads, near the current location of Albion Middle School. Burton Heazlit donated some of his farmland for this school. The seven-year-old Thomas Surrarrer, seated fourth from left in the first row, was the younger brother of teacher Edna Surrarrer (third row, right) and eventually headed the biology department at Baldwin-Wallace College.

The District No. 3 Sanderson Schoolhouse was situated at Sanderson Corners at the intersection of Drake and Hunt Roads. The building was later converted to a residence that still stands today.

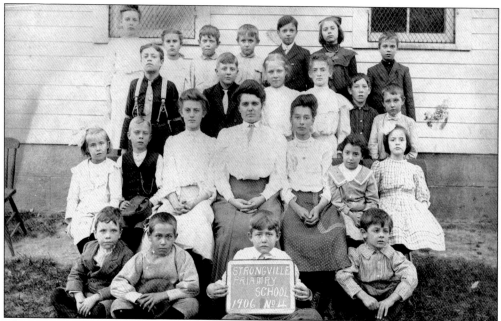

The students of the District No. 4 Center Schoolhouse apparently did not double-check their spelling before sitting for this photograph in 1906. This school shared space with the high school students in the Old Town Hall. The nine-year-old Olive Bedford, great-granddaughter of early Strongsville settler Thomas Bedford and future teacher of 28 years, appears second from left in the fourth row. Olive Bedford Allen Elementary was dedicated on Park Lane Drive in 1960.

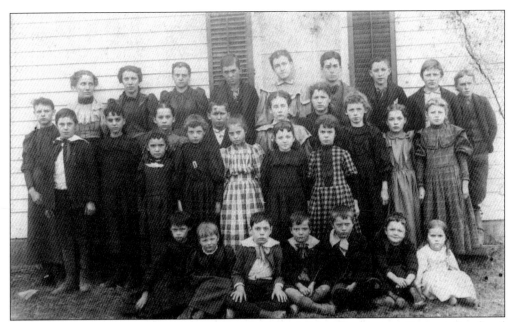

This portrait of the students of the District No. 5 Vigil Schoolhouse, near Prospect Road and Depot Street (Westwood Drive), was taken during the 1896–1897 school year. Frank Siedel (first row, third from left) and his brother Joseph (third row, left) later owned the general store at that location.

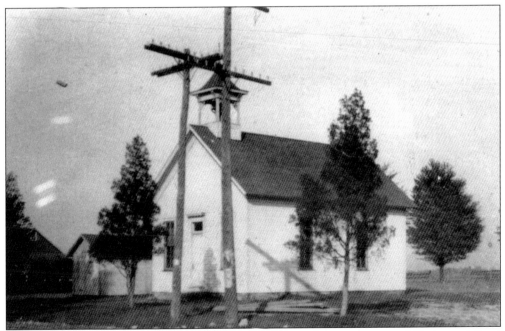

The District No. 6 Fenimore Schoolhouse, standing at the intersection of Drake and Pearl Roads, typified the design and appearance of Strongsville's district school buildings. When the one-room schoolhouses eventually closed, most were converted into residences or other uses, and 8 of the 10 structures remain.

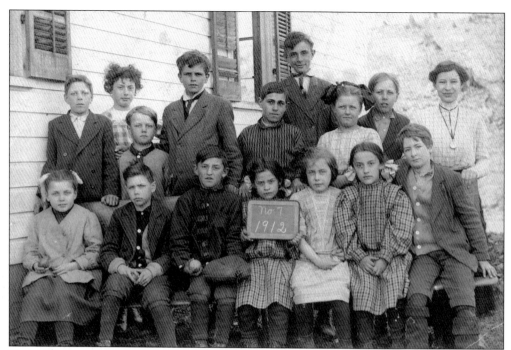

This 1912 image of the District No. 7 Slab Hollow Schoolhouse on old Howe Road (Mill Hollow Lane) shows a young Edna Surrarrer (third row, right) early in her distinguished teaching career. Cecil (first row, second from left) and Neil Howe (second row, left) were sons of store owner Carl Howe. Maude Roy (third row, left) was the daughter of Roy's Mill operator William Roy.

The District No. 8 Beebetown Schoolhouse was among the last five district schoolhouses to close in 1923. Pictured at recess time, it stood at the corner of Marks and Boston Roads. As seen here, automobiles and horse-drawn wagons often shared the roadways in the early 20th century.

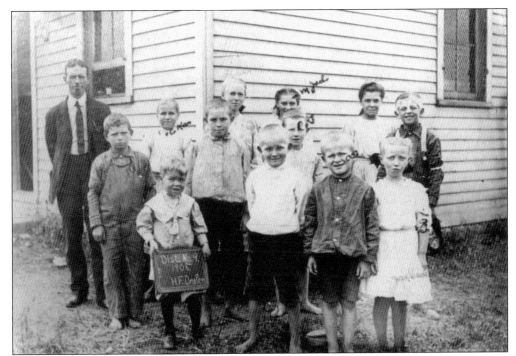

Harlie Draper taught for 20 years in one-room schoolhouses in Strongsville and Royalton (North Royalton). Here he poses with his students at the District No. 9 Dykes Schoolhouse in 1908. The school was located on the northwest corner of Prospect and Fair Roads, near Berea.

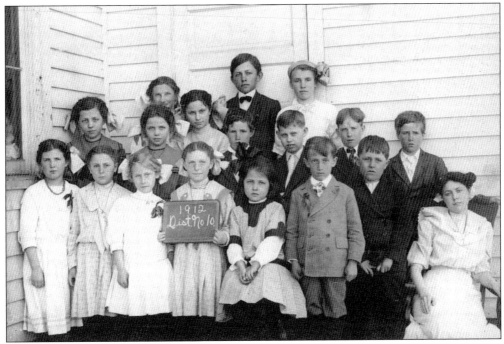

The District No. 10 Robbins Schoolhouse was one of the first in the district to close in 1916. Situated on Lunn Road west of Prospect Road, its students are shown here in 1912.

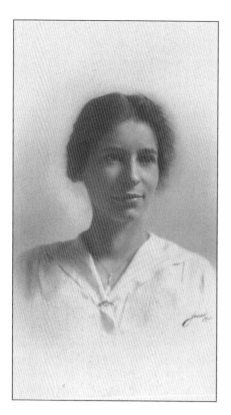

Edna Surrarrer, pictured in 1919, was born in 1892 and spent the majority of her 42-year teaching career in the Strongsville and Euclid schools. Her first job was in the Slab Hollow Schoolhouse, where she walked two and a half miles daily from her home at Webster and Whitney Roads. In 1966, Edna Surrarrer Elementary was dedicated on Priem Road. She died in 1986 at age 94.

Dexter Franklin Drake, the brother of Elmer Drake, was born in 1876 and was a teacher in Strongsville for 37 years. Dexter Drake Elementary was dedicated in his honor in 1955, 10 years after his death. The original elementary school, adjacent to the high school on Pearl Road, was relocated to a new building on Albion Road in 1975.

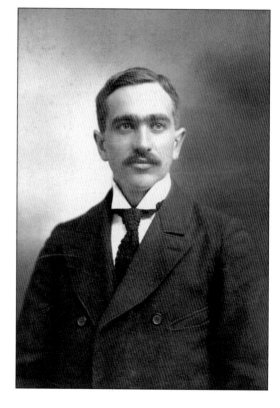

Edith Whitney was the great-granddaughter of Guilford Whitney, one of the original pioneers to arrive in Strongsville with John Stoughton Strong in 1816. She was an active member in the Congregational Church and a teacher in the Strongsville schools. Shown in 1913, she died in 1954. Edith Whitney Elementary, located on the road named for her ancestor, was dedicated in her memory in 1963. (Whitney Elementary.)

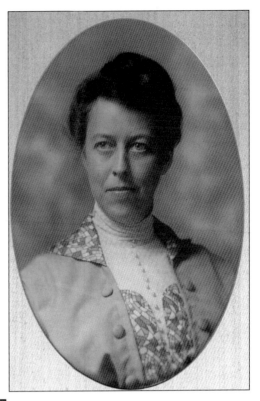

Sylvester R. Zellers was born in 1897 and retired in 1967 after 40 years as a teacher, of which 24 were spent in Strongsville. S. R. Zellers Elementary was dedicated on Cook Avenue in 1968. He was married to Edgar Merrick's granddaughter Helen Merrick and died in 1980 at age 82.

Bessie M. Kinsner was born in 1912 and taught in the Strongsville schools from 1947 to 1975. Here she attends the groundbreaking of Bessie M. Kinsner Elementary on Waterford Parkway, which was dedicated in 1998. She died in 2004 at age 92. (Mary Arpidone.)

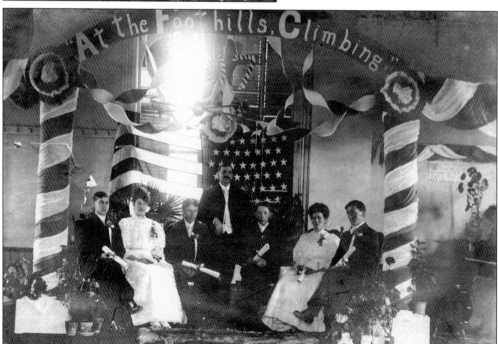

The Strongsville High School class of 1907 (with teacher and school superintendent Elmer Drake standing) includes, from left to right, Leland Drake, Julia Surrarrer, Arthur Southwick, Albert Morley, Ruby Sanderson, and Wallace Ogilvy.

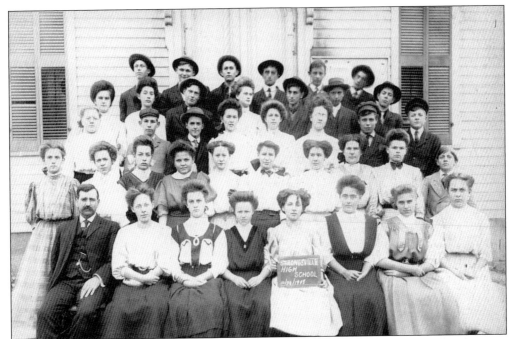

Elmer Drake is seated in the first row at left with the Strongsville High School student body at the Old Town Hall on October 30, 1908. These were the last students to occupy this building. The newly constructed high school on Pearl Road was dedicated two months later.

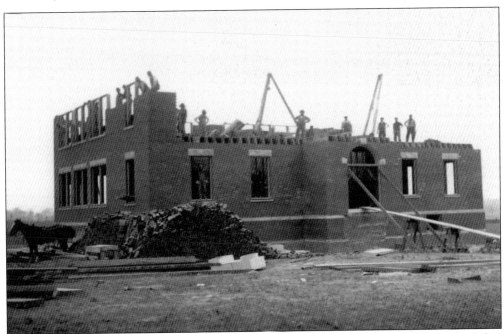

The school board established the first high school in 1859, but citizens later voted to rescind that action. The board formally established Strongsville High School in 1896 at the Old Town Hall, with the first class graduating in 1901. A new high school is shown here under construction at a time when horses were still utilized for heavy hauling.

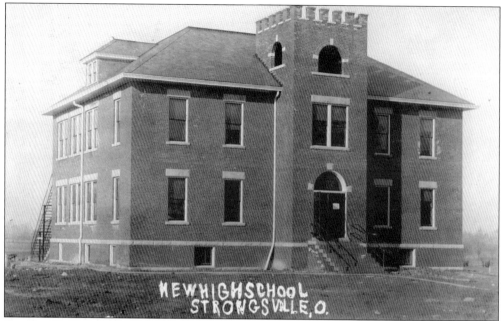
Strongsville High School was dedicated at its Wooster Pike location on December 29, 1908.

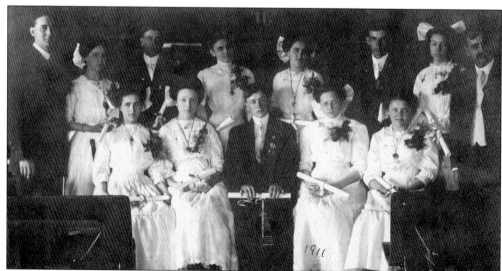
By the time Strongsville High graduated its 1911 class, a second high school teacher, Herbert Bedford (second row, left), had joined the staff with Elmer Drake (second row, right). In the first row at right is new graduate Helen Muraski, who went on to teach from 1916 to 1950, all but two of those years in Strongsville. Helen Muraski Elementary was dedicated on Royalton Road in 1957.

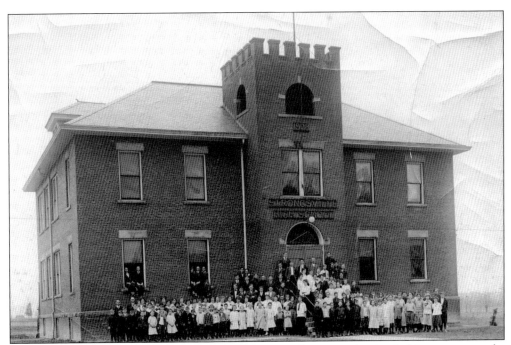

Strongsville High School, shown above upon its completion, maintained this appearance for less than a decade. As the community grew, an addition quickly became necessary, and the building was expanded during the 1916–1917 school year. The newly finished addition, shown below, was connected to the front of the original structure, which is still visible to the rear and also just below the flagpole. By 1921, a new high school with an attached gymnasium had been built behind the remodeled structure, which then served as Strongsville Elementary School. In that era, there was no junior high; elementary students began high school in the seventh grade. Today the structure below is the headquarters of the Strongsville City Schools, and the 1921 high school building is now a portion of Center Middle School.

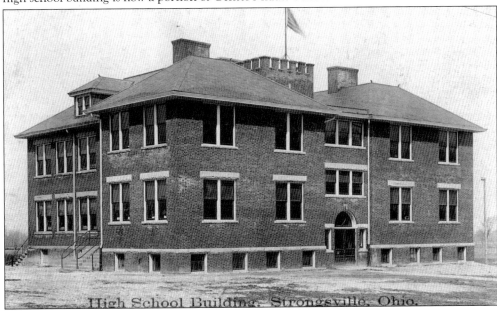

Strongsville baseball team members pose on the commons in 1908, where they played in the old Western Reserve League on Saturday afternoons. Pictured here, from left to right, are the following: (first row) Elmer Drake, Leon Richards, and Leland Drake; (second row) Herbert Bedford, George Burnham, Fred Burnham, Charles Bolton, Ezra Wilkinson, and Myron Bedford; (third row) Clarence Meacham, George Merrick, Corral Hunt, Marvin Gray, Vernie Clement, Harrison Morton, and Clarence Wilkinson.

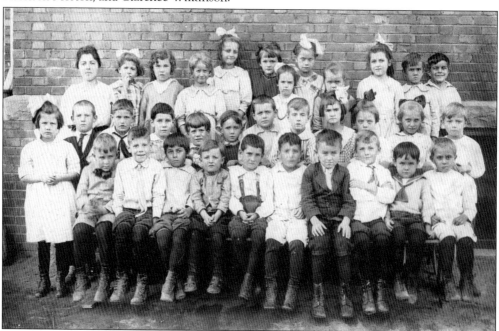

In 1918, the Center District School's first- and second-grade classes were held in the high school building. The seven-year-old Charles Graves (first row, second from left) would grow up to be chief of the Strongsville Fire Department in 1942 and serve in that capacity until his death in 1972.

The high school class of 1922 included Martin Taliak, who graduated from the University of Michigan Medical School in 1930. During World War II, he served in the Pacific as a neurosurgeon. He eventually became chief of surgery at Southwest General and Deaconess Hospitals and was an assistant professor of medicine at Case Western Reserve University.

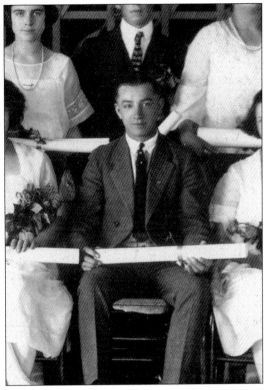

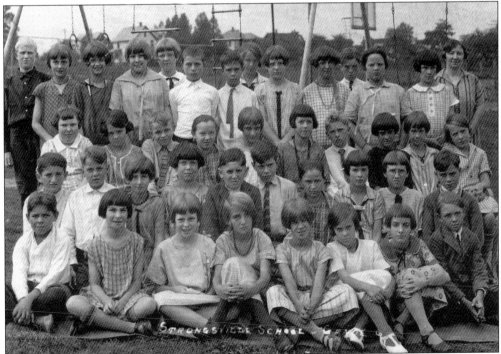

The sixth-grade class of Strongsville School is shown in 1925. During that era, local children completed their elementary studies and embarked on six years of high school.

The Strongsville High School band was organized in 1925 under renowned West Tech High School band director Peter McCormick (second row, right). Members in 1926 include, from left to right, the following: (first row) Frank Wick, Frederick Wilder, Margaret Fish, Mary Keenan, Russell Smith, Marie Morton, Irma Graves, Agnes Keenan, William Wilson, Robert Wick, William Bucey, Bernard Siedel, Howard Draper, George Siedel, Frieda Szentpetery, Wilma Burnham, and Arthur Blythin; (second row) Annalee Wilder, Robert Bucey, Edith Wilder, Ruby

Calvert, Agnes Carpenter, Hilda Finley, Eldon Roe, Norris Crumpler Jr., Clark Fish, William Cooper, Ruth Poots, Winifred Thompson, Viola Bassett, Zella Schade, Robert Blythin, Carl Smalley, and Joseph Blatnik; (third row) Gordon Morton, George Birmingham, Arthur Moore, Roy Finley, Ellis Clement, Everett Adams, Raymond Calvert, Harley Musser, Willard Millar, Lawrence Neumeyer, Charlotte Poots, and Margaret Cooper.

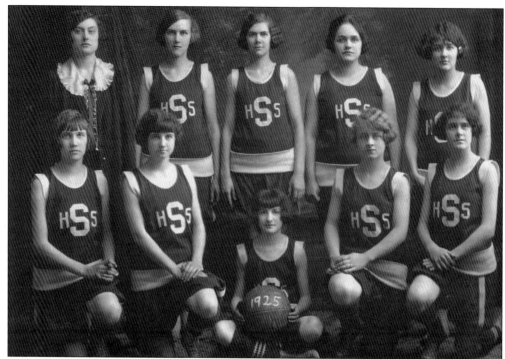

Maude Roy (second row, left) taught mathematics and coached the 1925 Strongsville girls' basketball team. Her father, William Roy, operated Roy's Mill for 32 years. She later married Howard Hirt, the son of Hirt's Greenhouse founder Samuel Hirt.

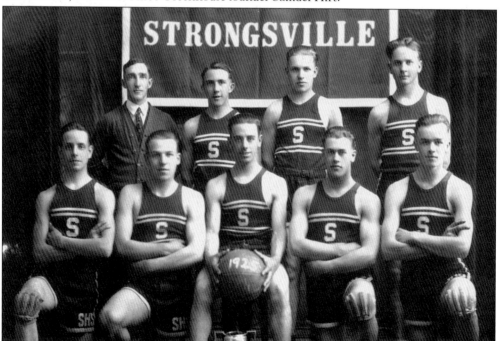

In 1925, the Strongsville boys' basketball team includes Robert Poots (first row, right), future Strongsville police chief from 1942 until his death in 1956.

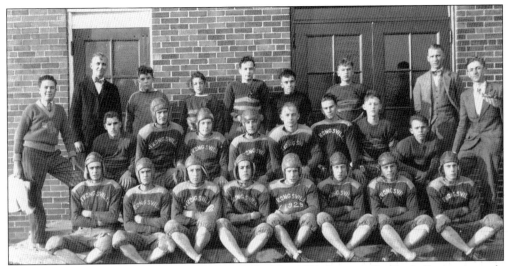

In the days of leather helmets and no face masks, the 1929 Strongsville football team is ready for action.

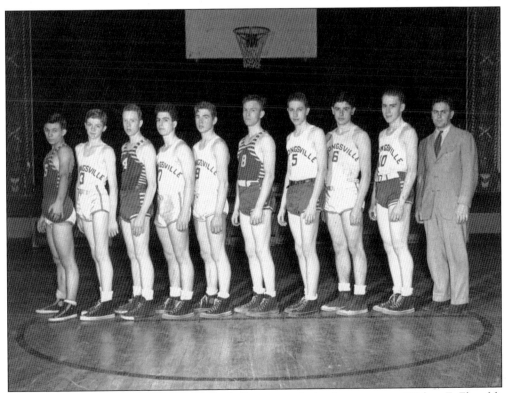

In 1947, Strongsville's ninth-grade basketball team includes future mayor Walter F. Ehrnfelt (fourth from left).

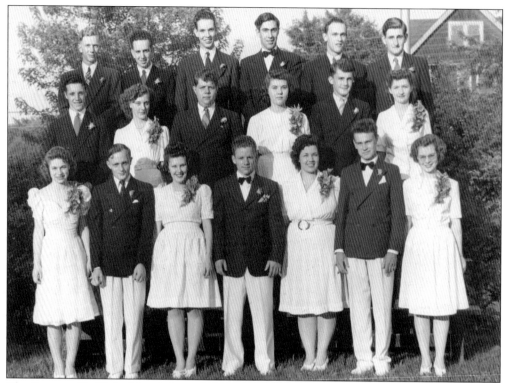
The Strongsville High School class of 1944 is dressed for graduation.

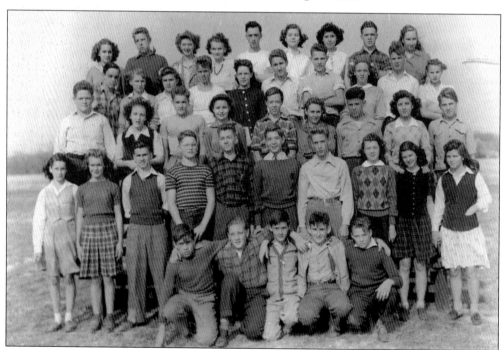
Strongsville students pose in the 1950s, during which time the village population grew from 3,500 to 8,500.

This photograph of the student parking lot was taken prior to the construction of an addition to the high school in 1952. The building shown is a portion of the high school structure built in 1921. (CSU.)

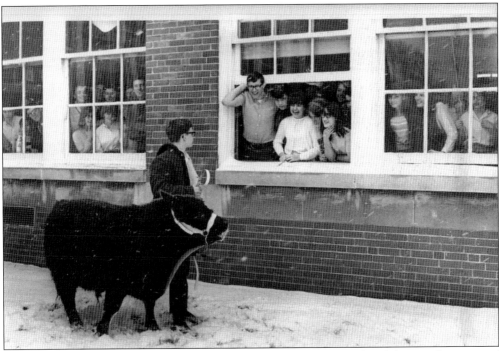

A Strongsville Junior High School youth brought a "friend" to school with him in the winter of 1968, to the delight of his fellow students. (CSU.)

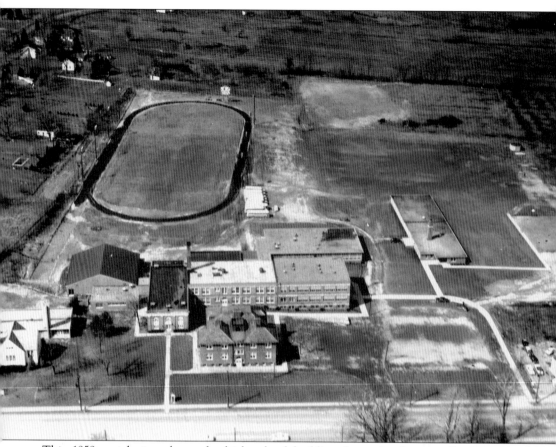

This 1958 aerial view shows the high school building (now the Strongsville City Schools building) in the foreground. Directly behind it is the 1921 high school and gymnasium with the 1952 additions (including a newer gymnasium to the left). The single-level structure to the right is the original Dexter Drake Elementary. The athletic field was added in 1941–1942. The Strongsville Jaycees financed construction of a new stadium on that field and named it in honor of Dr. Martin Taliak following his death in 1962. The United Methodist Church at lower left was remodeled that same year.

Voters approved a $1.1 million bond issue in 1962 for the construction of a new high school on 70 acres of purchased land on Lunn Road. Strongsville High School was completed in 1964 and has been altered and expanded several times. Today it has one of the largest enrollments in the Greater Cleveland area. (Amy Anter.)

Mike Catan, president of Pat Catan's Craft Centers, spearheaded and contributed $400,000 toward a massive fund-raising campaign to construct Pat Catan Stadium, named for his father and dedicated in 2002. It is home to one of the Cleveland area's top high school football programs. The Strongsville Mustangs have reached the Ohio state playoffs 11 times in the first 13 seasons under coach Russ Jacques since his hiring in 1993. (Amy Anter.)

When Leonard O. Bean took office as Strongsville's second mayor in 1930, there were 38 miles of unpaved dirt roads in the village. At the time of this 1911 photograph, undoubtedly there were many more such roads, which were often in frozen condition in winter or muddy in spring. Automobiles like this White Steamer occasionally had some difficulty reaching their destination, especially with a full load of passengers.

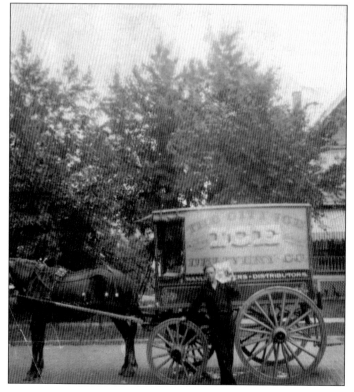

Some of the main thoroughfares like Wooster Pike (Pearl Road) were eventually paved with brick and made easily navigable for automobiles—and for horse and buggies delivering ice to residents' doors.

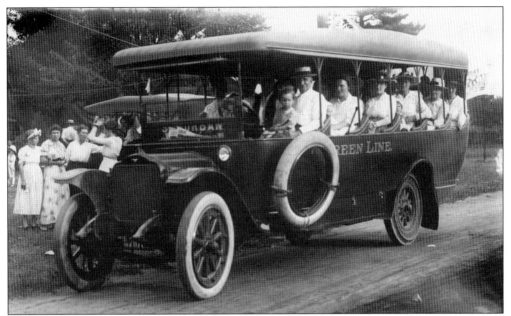

The Green Line bus service ran four times daily from Medina, Brunswick, Valley City, and Strongsville, north on Wooster Pike to Brooklyn. Another route ran from York to Royalton Road and west to Roy's Mill. The Green Line operated for many years before being sold to a company eventually purchased by Greyhound. This photograph was taken at the commons in 1916.

Workers pick strawberries on a Lunn Road farm in the early 20th century. The Frederick Stone home can be seen in the distance to the right. Much of what little farmland remains in Strongsville is located in this same western area of the city, near the Lorain County line.

The worst tornado disaster ever to hit Strongsville took place on Palm Sunday, April 11, 1965. The category F4 twister caused massive damage in the area. This view looks east from Atlantic Avenue in the aftermath. (Lee Sprague.)

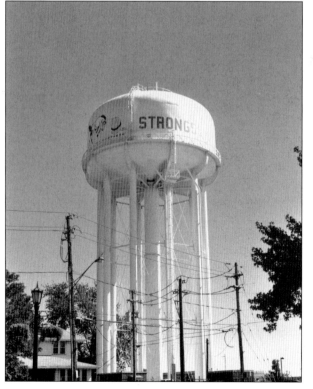

Strongsville's water tower has been a familiar city landmark since the early 1960s, rising over 100 feet above the commons. Many residents will remember that it had once been painted green. Local cartoonist Tom Wilson, creator of the Ziggy comic strip, first painted his signature character atop the tower on May 26, 1975. (Amy Anter.)

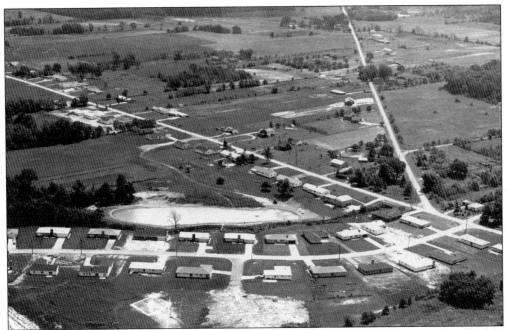

Strongsville continued to grow in the 1950s and 1960s with new home construction. The village became a city in January 1961, four months after this photograph was taken. In the foreground are newly built homes on Greenbrier Drive near the intersection of Drake and Hunt Roads, with Benbow Road at right. Today much of this area comprises the residential developments of Spyglass Hill, Bent Tree, and Chandler Commons. (CSU.)

This 1951 aerial view of Strongsville faces in a northeasterly direction, showing the intersection of Pearl and Royalton Roads, the Old Town Hall, and the new town hall building just beyond it. The photograph highlights the fact that despite its growing population, Strongsville in the early 1950s was still a rural community beyond the center of town and the main thoroughfares. (Alan Hirt.)

This aerial image, also from 1951, faces to the southwest. It reveals that Royalton Road at one time curved to the left around the commons and past the Old Town Hall. A separate road formed to the right past the new town hall facility and continued around the commons past the Strong House. It became Westwood Drive on the other side of Pearl Road. (Alan Hirt.)

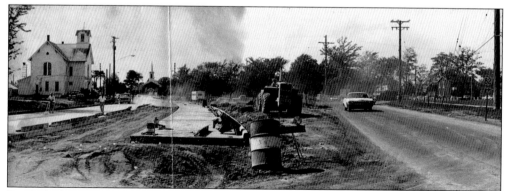

In 1965, the old Ordner farmhouse was razed, Royalton Road was rerouted toward the Pearl Road intersection, and the road bearing to the right, past the 1952 town hall building, was eliminated. The Strong House is visible to the right. (CSU.)

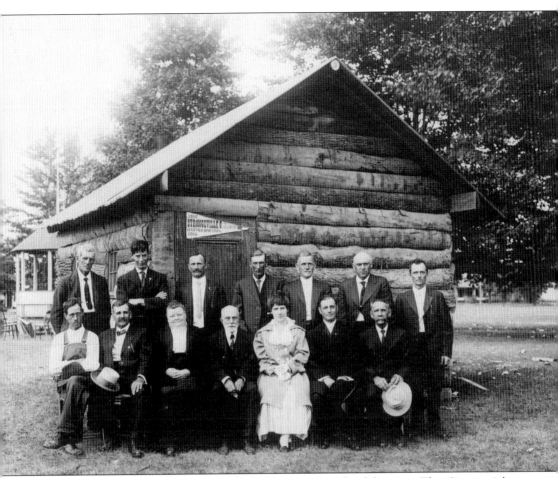

For three days in August 1916, Strongsville held a centennial celebration. The Centennial Committee, which organized the event, included some prominent figures in Strongsville history. In front of a replica log cabin (similar to the cabin built for the 1966 sesquicentennial) are, from left to right, the following: (first row) Bert Davison (Strongsville game warden for 25 years), Elmer Drake (longtime teacher and superintendent of schools), Eva Drake Wheller (daughter of Charles Drake and wife of William Wheller), Dr. James B. McConnell (physician and farmer), Mary Kaatz Roe (wife of prominent Methodist church member Elias Roe and the first woman elected to the board of education), Rev. Clarence Doane (pastor of the Congregational Church), and Richard Gibbons (deacon of the Congregational Church); (second row) William Smith (builder of the Buckeye Pipeline and Cleveland Southwestern Interurban Railway), Roy Pierce (founder of Pierce Motor Sales), Henry Bick (farmer and owner of former Fenimore Schoolhouse), Lawrence Bedford (owner of Bedford-Howe Hardware Store and township trustee), M. J. Earle, William Roy (owner and operator of Roy's Mill), and Allison Sanderson (farmer and son of Aretus Sanderson).

Coca-Cola was the refreshment of choice at the centennial, where a bottle could be purchased for 5¢.

Automobiles and horse-drawn carriages alike were participants in the centennial parade. The sense of community pride felt by Strongsville's citizens in 1916 endures to the present day. Attendance at the three-day event was 2,500, approximately twice the township's population at the time. More than 40 descendants of John Stoughton Strong reunited for the occasion.

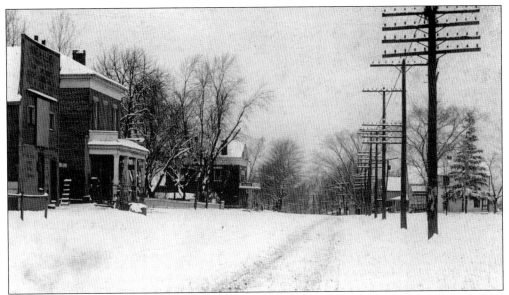

This winter view, looking northbound on Wooster Pike, illustrates the quiet tranquility of life in Strongsville Township in the early 1900s.

The Freedom Trail is a unique memorial tribute to Strongsville's veterans. It is a mile-long path that features gardens representing each war. A plaque placed at each garden summarizes the history of that particular conflict. Along the trail are a gazebo and a brick walkway with the names of local soldiers. Next to the gazebo is the monument shown above, a gift from Lee and Irene Sprague. (Amy Anter.)

Velda Chapman is pictured at left in 1959 with three of her Creative Arts League colleagues, practicing the talent for which she will always be known to Strongsville residents. (CSU.)

In July 1932, three youths try their luck at Bonnie Park near one of the last remnants of old Albion: John Stoughton Strong's mill. The mill is long gone, but Bonnie Park remains popular for fishing, biking, picnicking, and simply enjoying a summer day. The Cleveland Metroparks system in Strongsville is untouched by development and offers miles of abundant green space for year-round enjoyment. It is one of the city's treasures. (CSU.)

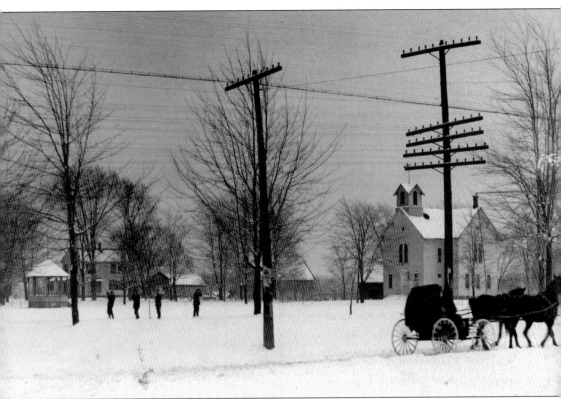

A horse-drawn carriage rides down the old Wooster Pike in this early-20th-century winter scene on the commons, John Stoughton Strong's gift to his beloved Strongsville. The city has grown and prospered over nearly two centuries into one of northeastern Ohio's most desirable communities, and residents and visitors still flock to the commons for concerts, festivals, and community gatherings. The four men shown taking target practice in the background on this winter day could look in any direction and observe a relic of Strongsville's past: the Strong House, the Pomeroy House, the Congregational Church, the Old Town Hall. From that same spot over a century later, those vintage landmarks still encircle the commons and its clock tower in a charming blend of the old and the new. "Strongsville is unique," Mayor Walter F. Ehrnfelt said in 1988. "I don't know of another city that's done so much to preserve its historical past." Strongsville is a vibrant city that looks forward to a bright future, but always with reverence to its rich heritage.

ACROSS AMERICA, PEOPLE ARE DISCOVERING SOMETHING WONDERFUL. THEIR HERITAGE.

Arcadia Publishing is the leading local history publisher in the United States. With more than 3,000 titles in print and hundreds of new titles released every year, Arcadia has extensive specialized experience chronicling the history of communities and celebrating America's hidden stories, bringing to life the people, places, and events from the past. To discover the history of other communities across the nation, please visit:

## www.arcadiapublishing.com

Customized search tools allow you to find regional history books about the town where you grew up, the cities where your friends and family live, the town where your parents met, or even that retirement spot you've been dreaming about.